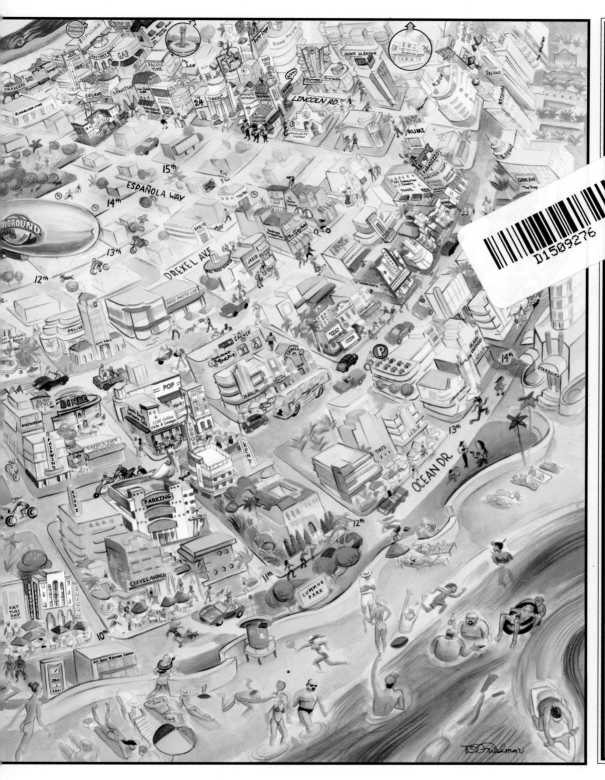

South Beach Deco
Step By Step

Iris Garnett Chase
Susan Russell, Photographer

Schiffer Publishing Ltd

4880 Lower Valley Road, Atglen, PA 19310 USA

This book is dedicated to the memory of Jocelyn Rataiczak, who loved South Beach and gave so much of herself to The Miami Design Preservation League.

Library of Congress Cataloging-in-Publication Data

Chase, Iris Garnett.
South Beach deco : step by step / by Iris Garnett Chase ; Susan Russell, photographer.
p. cm.
ISBN 0-7643-2190-0 (pbk.)
1. Art deco (Architecture)—Florida—Miami Beach—Guidebooks. 2. Art Deco Historic District (Miami Beach, Fla.)—Guidebooks. 3. Miami Beach (Florida)—Buildings, structures, etc.—Guidebooks. 4. South Beach (Miami Beach, Fla.)—Buildings, structures, etc.—Guidebooks. I. Title.

NA735.M4C52 2005
720'.9759'381—dc22

2004025680

Copyright © 2005 by Iris Garnett Chase

Designed by "Sue"
Type set in BroadwayEngraved BT/Humanist 521 BT

ISBN: 0-7643-2190-0
Printed in China

Published by Schiffer Publishing Ltd.
4880 Lower Valley Road
Atglen, PA 19310
Phone: (610) 593-1777; Fax: (610) 593-2002
E-mail: Info@schifferbooks.com

For the largest selection of fine reference books on this and related subjects, please visit our web site at
www.schifferbooks.com
We are always looking for people to write books on new and related subjects. If you have an idea for a book please contact us at the above address.

This book may be purchased from the publisher.
Include $3.95 for shipping.
Please try your bookstore first.
You may write for a free catalog.

In Europe, Schiffer books are distributed by
Bushwood Books
6 Marksbury Ave.
Kew Gardens
Surrey TW9 4JF England
Phone: 44 (0) 20 8392-8585; Fax: 44 (0) 20 8392-9876
E-mail: info@bushwoodbooks.co.uk
Free postage in the U.K., Europe; air mail at cost.

Contents

Acknowledgments

I thank my husband, Barry Chase, for giving me his time and his love, and for guiding me in the best of all directions—south to Miami Beach.

I also am so grateful to have had the privilege of working with Susan Russell, whose photos make this book special. She made herself available night and day, and never said "no" to any request. She would like to give special thanks to Dick and Hilary Russell, Ron and Carla Cold, and to Michael Muñoz.

Chapter One

Introduction
South / West / North / East?

South Beach is a pleasure-packed square mile of palm trees, ocean breezes, and long subtropical days and nights. If you're like most people, you've already heard about the glamour; the beautiful-people-parades along Ocean Drive and Lincoln Road; the gentle, turquoise Atlantic surf; the warm weather and the "hot" clubscene; and, of course, the Art Deco architecture.

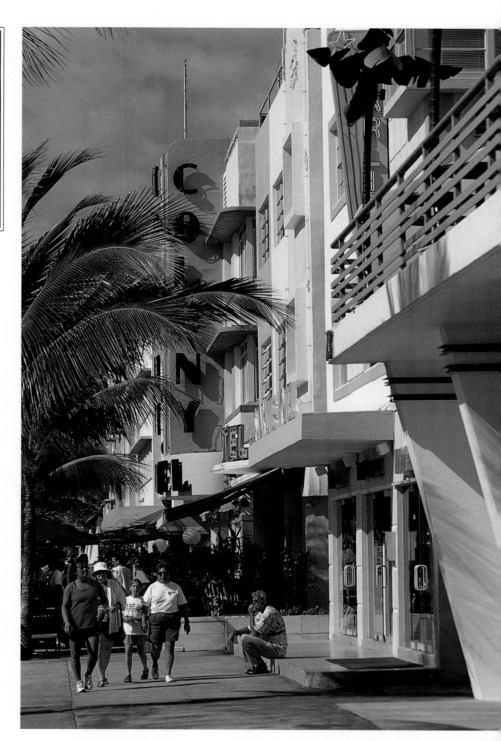

From 8th St. and Ocean Drive, looking south.

Almost always turquoise, The Atlantic Ocean at South Beach.

But first, what do we mean when we talk about "South Beach"? You may be surprised to learn that there is no "official" place called South Beach. Officially, South Beach is just the southern part of Miami Beach, which runs south to north — from Biscayne Street at the southern tip of the island known as "Miami Beach" to 87th street in the north. The "South Beach" name has come to mean the area between the southern tip of Miami Beach and 23rd Street. One definition of "South Beach" has grown up around the National Historic Preservation District that was declared to exist in 1979. According to the designation of Historic Preservation, the District runs from 6th Street in the south to 23rd Street in the north, and from the Atlantic Ocean on the east to the shores of Biscayne Bay on the west (a total of about one square mile, or about two and one half square kilometers). (If you don't like the idea of walking, there's a local shuttle that will take you throughout South Beach for a mere twenty-five cents. Look for the "Electrowave" or "The Local" should you need a lift.)

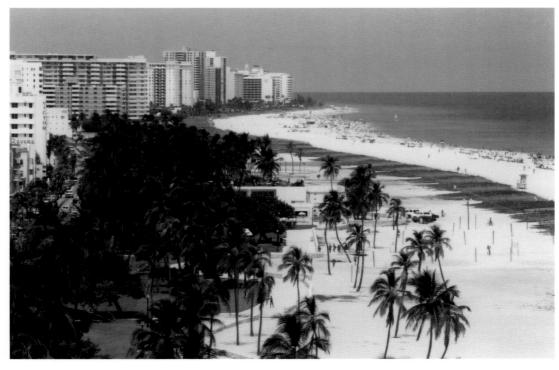

The shore at South Beach, looking north.

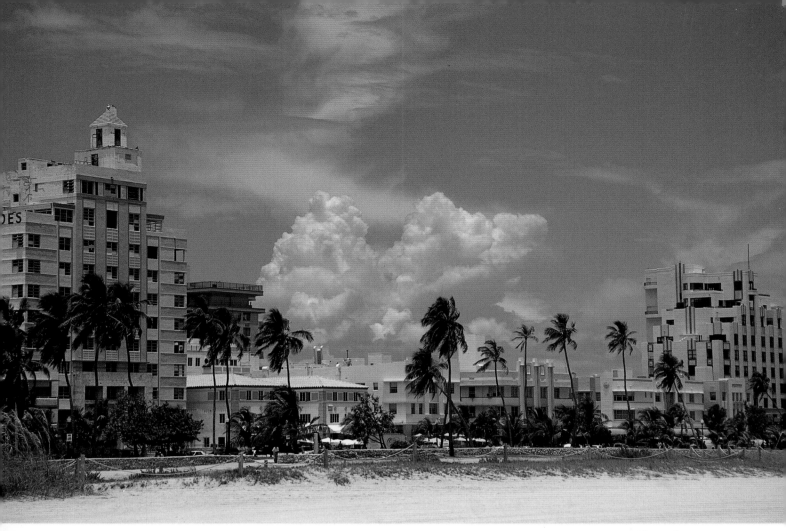

Buildings prior to restoration on Ocean Drive between 12ᵗʰ and 13ᵗʰ streets.

Once upon a time not so long ago, up until about 1985, it was not so great to be known as a part of anything called "South Beach," because the area had physically and spiritually deteriorated. It had become the resort-of-last-resort. Then came the Historic District designation, which was the great achievement of a feisty woman named Barbara Baer Capitman and a small band of fellow visionaries who formed the Miami Design Preservation League. After that, things began to turn around for the area known as South Beach. In the early years of this twenty-first century, in fact, the "South Beach" name has become a virtual trademark for the Riviera-type atmosphere and pleasures of this Art Deco district. It has become such a well known name that in other areas of Miami Beach, and even as far north as Fort Lauderdale, the "South Beach" name has become a useful marketing tool for hotels, restaurants, clubs, and retailers.

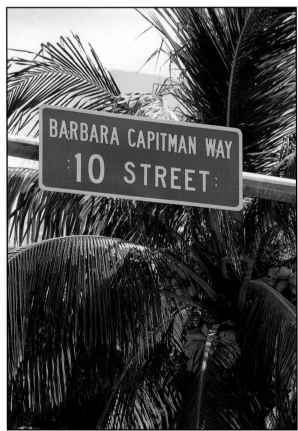

Barbara Capitman Way, named after the founder of the Miami Design Preservation League.

But if you've come to South Beach especially for distinctive "Nautical Art Deco" architecture, you've come to the right place. The indirect effect of receiving an official United States government designation as a Historic District was to assure a certain amount of political commitment to the preservation of what had been nationally recognized as "special." The result of that heightened political sensitivity (and the profit opportunities accompanying it) has been preservation of the "wedding-cake" buildings constructed in South Beach during the first half of the twentieth century. Some of these buildings were just barely saved, preserving most of the "icing-on-the-cake" details. And many of them were saved from being destroyed or converted into look-alike "cookie-cutter" buildings. This specialness soon attracted the attention of artists and investors who saw the value of the distinctive architecture and the enduring subtropical climate, sandy beaches, and turquoise ocean. And with its accessibility from other US and foreign cities, its importance in the world could only rise higher and higher…and it has!

Detail from Art Deco building at 1321 Pennsylvania Ave.

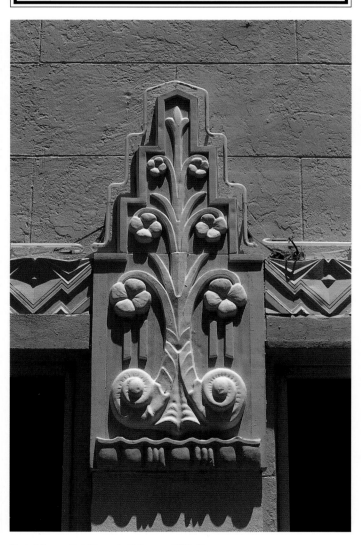

Detail from Art Deco building on Fifth St.

Detail from Art Deco building at 347 Washington Ave.

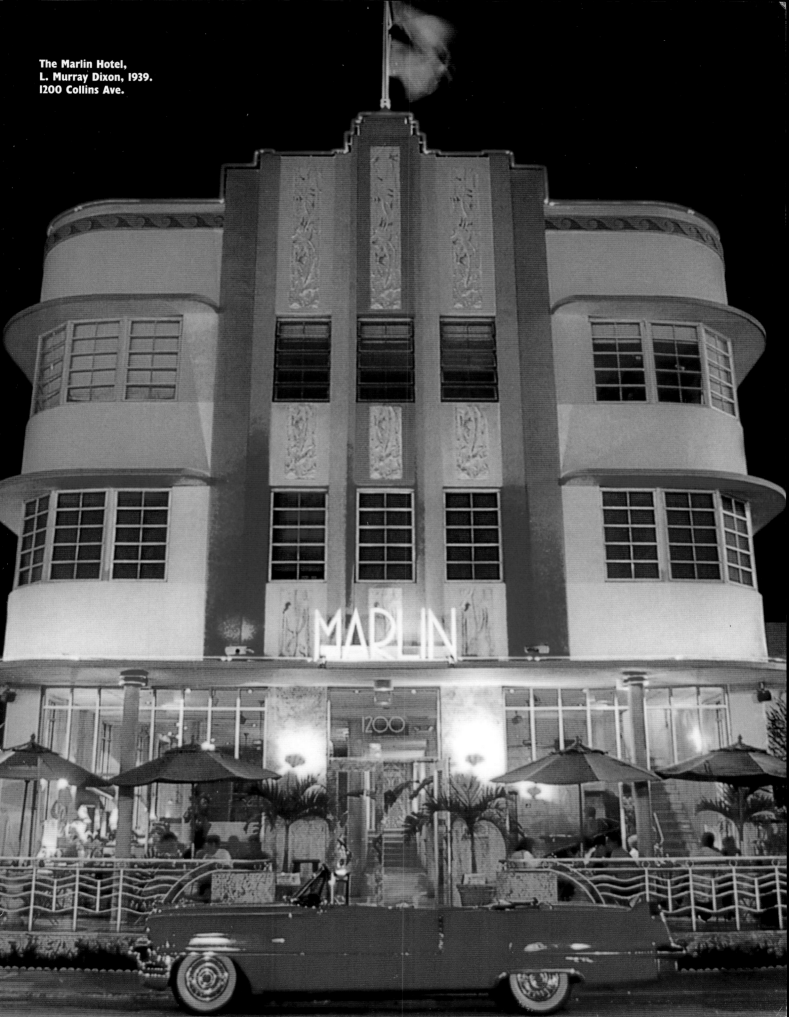

The Marlin Hotel,
L. Murray Dixon, 1939.
1200 Collins Ave.

One of many fashion shoots on Ocean Drive.

The rest, as they say, is history. The last decade of the twentieth century and the first few years of the twenty-first have seen South Beach (with all its different definitions) become a magnet for the rich and famous, the beautiful and glamorous, and the ambitious and creative. Among these visitors (some of whom, every year, become new permanent residents) has also been a steady and growing stream of lovers of the distinctive Miami Beach "Art Deco" style.

The preservation and promotion of this Miami Beach Art Deco style is the particular mission of Barbara Baer Capitman's organizational creation, the Miami Design Preservation League ("MDPL"). The MDPL office is located in the heart of the Deco district (1001 Ocean Drive), along with its Art Deco Museum and The Art Deco Welcome Center. Today, MDPL ranks as the oldest Art Deco society in the world (an unusual distinction for a US-based organization within a global movement) and is the key to many ways of enjoying the architecture of the South Beach area. From the Welcome Center, MDPL originates a regular schedule of Art Deco walking tours, which have been cited by many sources as one of the great values of any Miami Beach vacation. MDPL also provides a self-guided walking tour, which can be taken at your own convenience with the assistance of maps and other materials (all available at the Welcome Center), which will assure your basic appreciation of the Art Deco District. The signature Art Deco event held in South Beach each year is Art Deco Weekend, organized and presented by MDPL along Ocean Drive, usually in the middle of January.

While the tours offered by MDPL tend to be consistent in the structures you'll see and the history you'll learn, the specifics of the do-it-yourself tours that are recommended in this book will change between the time you read this and the time you start walking! That is because constant change seems to be the rule here. It is also what adds to the excitement. The locations of many of the restaurants, clubs, watering holes, and other pleasure sites, seem to change on a monthly basis. Because of the high value of South Beach, rents have become high as well. Those businesses that have consistently provided something special have been rewarded with loyal patrons, and many have remained. However, you're unlikely to see exactly the same variety of sites and sounds on Ocean Drive or Lincoln Road in October, let's say, as you enjoyed the previous January (so you must keep coming back!). What does not change from year to year, though, is the concentration of pleasure-sites along the routes that we are going to recommend in this book. While the names and even the styles may change, there seem always to be certain categories of Miami Beach spots that simply become better and richer over time. In other words, you may not always find the specific restaurant or beachside grill that we mention, but if you stay within the tours we recommend you are sure to come upon your own new discoveries on these routes, as well as visit the most enduring of the experiences that we suggest.

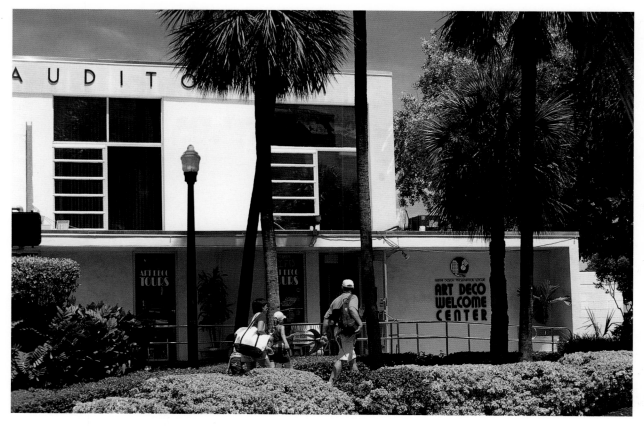

Art Deco Welcome Center and Art Deco Museum at 1001 Ocean Drive.

Who Actually Lives Here?

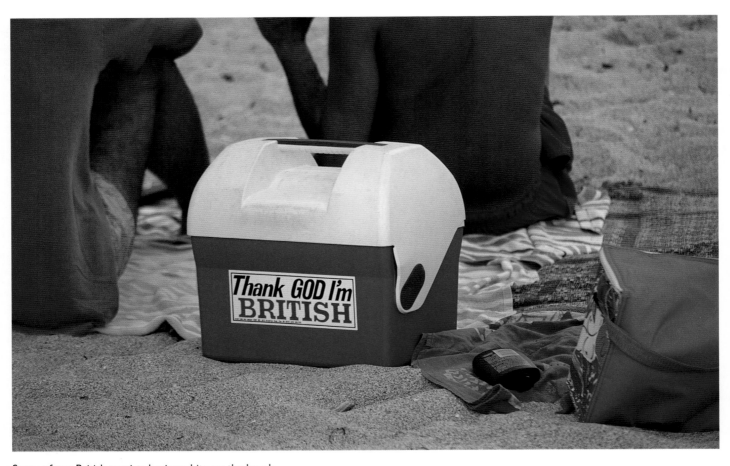

Some of our British tourists having a bite on the beach.

While you're filling your eyes with the architectural treats of Miami Beach, you can also have an equal amount of fun viewing the people you'll see and maybe even meet. Obviously a lot of these people will be visitors like you, but the city does have a permanent population of something like 85,000. While technically, geographically, and legally part of the United States, South Beach is a unique cultural mix that cannot be found anywhere else in the country. It is, in many ways, more temperamentally like the Mediterranean European coast or parts of Latin America. While walking the streets staring at the unique architectural (and human) shapes that you'll come across, you can't help but hear a variety of different languages – Spanish, of course (though, despite what you may have heard, you can also get along fine here just speaking good old American English), but also German, French, Brazilian Portuguese, Russian, Hebrew, and lots of British-Empire English as well. Just listening to the language mix will transport you to a foreign place, a place which exists only between the open sea and the City of Miami across Biscayne Bay. And, of course, this unique mix of spoken sounds also gives rise to a unique spectrum of musical sounds – not only the local versions of American dance music, pop-music, and the "urban" sound, but also salsa from Colombia, tango from Argentina, reggae from the English-speaking Caribbean, flamenco from Spain, meringue and bachata from the Dominican Republic, samba and more from Brazil, and, of course, the distinctive rhythm sounds of Cuba and Puerto Rico.

Along with all the exotic sounds, you'll have no trouble appreciating the exotic appearance of the locals. To make no bones about it, people are BEAUTIFUL here. Well, maybe not everybody; but the influence of sun, sea, and the warm weather has fostered a body-consciousness and a standard of public exposure that would get people arrested on the main streets of other American cities. You may see people walk into a restaurant here wearing nothing more than a bikini and a sheer "cover-up" – not for nothing has South Beach been called the "Sexiest Place on Earth." And, in case you haven't already heard, the sexiness is across the board. Whether you're straight, gay, bisexual or not too sure about it, you're going to see many attractive people — some only barely wrapped.

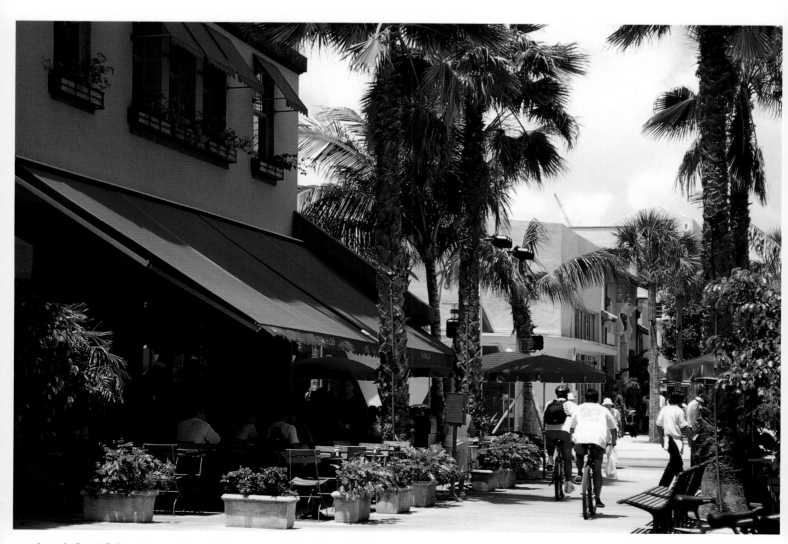

Lincoln Road Cafés offer people-watching opportunities, day and night.

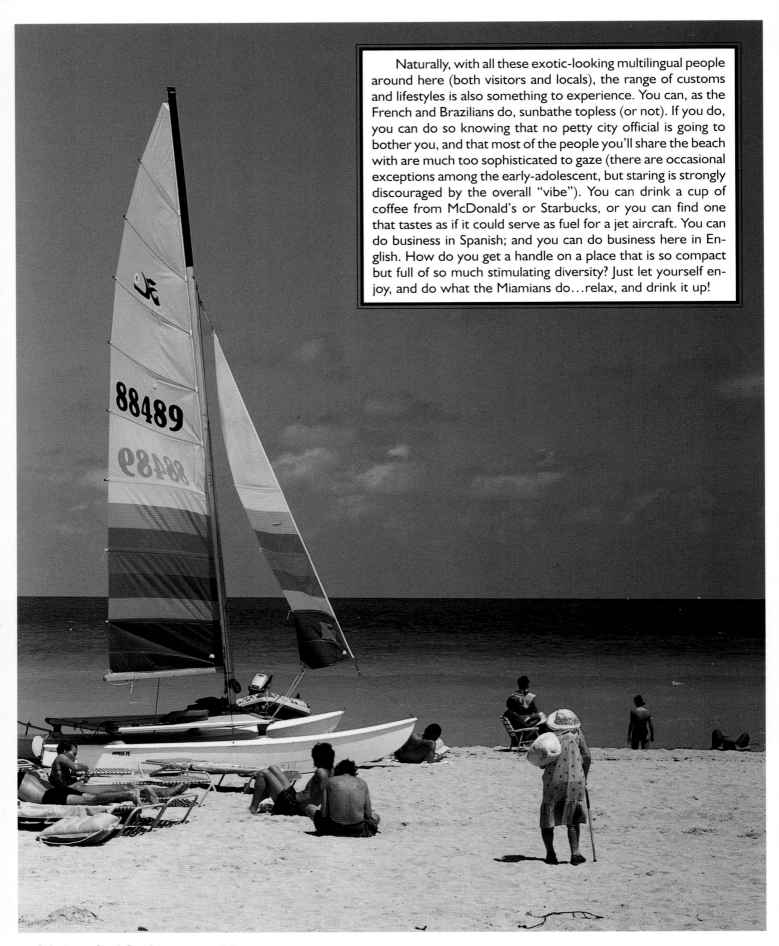

Naturally, with all these exotic-looking multilingual people around here (both visitors and locals), the range of customs and lifestyles is also something to experience. You can, as the French and Brazilians do, sunbathe topless (or not). If you do, you can do so knowing that no petty city official is going to bother you, and that most of the people you'll share the beach with are much too sophisticated to gaze (there are occasional exceptions among the early-adolescent, but staring is strongly discouraged by the overall "vibe"). You can drink a cup of coffee from McDonald's or Starbucks, or you can find one that tastes as if it could serve as fuel for a jet aircraft. You can do business in Spanish; and you can do business here in English. How do you get a handle on a place that is so compact but full of so much stimulating diversity? Just let yourself enjoy, and do what the Miamians do…relax, and drink it up!

Relaxing on South Beach is a major activity.

Chapter Three
What IS "Art Deco" Anyway?

As the Resident Artist of the Art Deco Center, I have often been asked the seemingly simple but actually very good question: "Exactly what IS this 'Art Deco' thing?" (I was once even asked "Who is Arthur Deco?"). Usually, this kind of question is asked with a bit of bashfulness or a sense that there might be something shameful about being ignorant of the Art Deco style. But, as I say, there is nothing at all wrong with this question, because the Art Deco label, like the South Beach label, has been placed on such a broad range of objects, goods, and services that it has become confusing for the average visitor to Miami Beach to separate the genuine article from everything else. Just consider that the Empire State Building in New York and many of the lifeguard stands which dot the sand of Miami Beach can both fairly be regarded as Art Deco.

➢
Empire State Building, New York City, built 1931. Postcard, Colourpicture Publication.

EMPIRE STATE BUILDING, NEW YORK CITY 52

10ᵗʰ St. Lifeguard Stand, Kenny Scharf and Bill Lane, 1994.

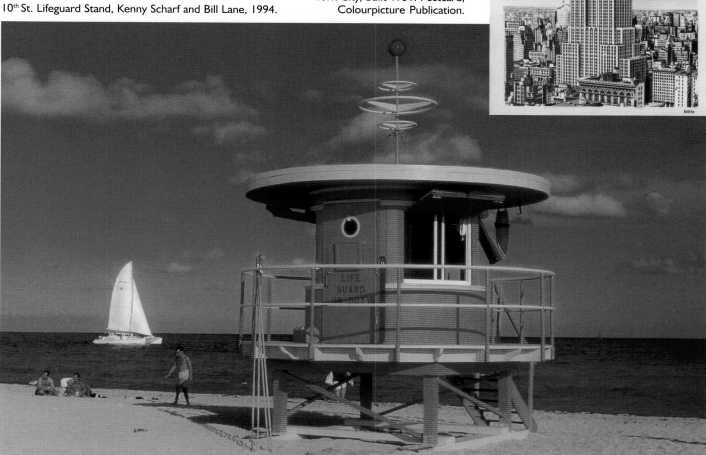

Deco Denim, South Beach Clothing Store…Call it old, call it blue, call it cotton…but Deco?

In Miami Beach you'll find clothing stores and supermarkets which call themselves "Art Deco." This is actually a very unsavory suggestion for a supermarket. After all, one of the few certain features of Art Deco is that it derives from a time between, at the earliest, 1919 and, at the latest, 1950. Few of us would want to eat some "fresh" fruit from an Art Deco market that really sold items from this period.

But, more seriously, here is the "short course" in what Art Deco really is and isn't.

1. It all started, at least officially, with the Paris Exposition of 1925, in which there was a celebration of the mode of style then known by its French name "Les **Art**s **Deco**ratifs." Hence the internationally known abbreviation "Art Deco." You'll run into some people who will insist that some pre-1925 works are in the Art Deco style, including some from before World War I and even as far back as the 1850s, but most of the stylistic current of the pre-1925 period is usually categorized as "Art Nouveau," the more filigreed type of style that was all the rage up until World War I.

2. So, in a sense, you're safe to call anything that was created with a sense of style during these years (1925 to 1950) as being, at least, from the "Art Deco Era."

Art Deco Market on Washington Ave, and 14th St. …Don't let the name fool you — the food is fresh.

3. More specifically, there are certain styles of architecture, furniture, clothing, and machines that are especially worthy of the Art Deco label, no matter what year they might have been created. If you take the famous walking tour that is offered by the Miami Design Preservation League and originates from the Art Deco Center, you'll learn a lot more, for example, about the curved shapes and something called "the rule of three" ➢

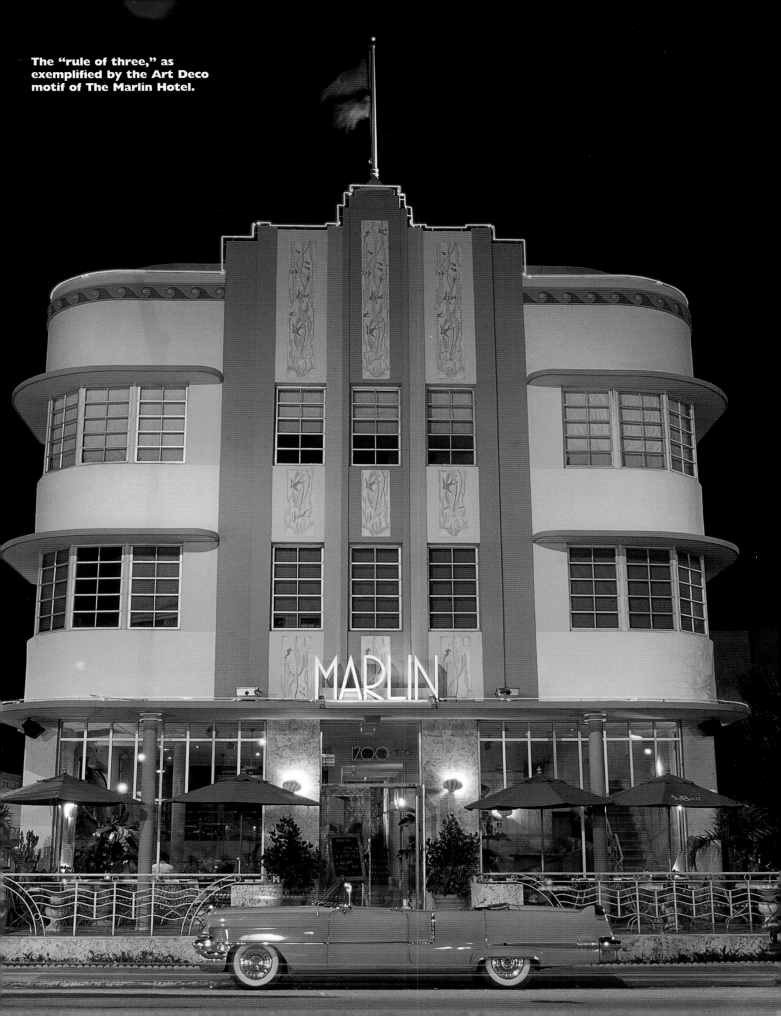

The "rule of three," as exemplified by the Art Deco motif of The Marlin Hotel.

that characterizes the Art Deco themes in South Beach's buildings. (The "rule of three" refers to the three basic elements of a building's geometric facade — the center element being the strongest or the most dramatic, and on either side two usually similar elements or structures. The result is a pleasing symmetry that can be found in so many Art Deco buildings.) Likewise, if you think about the "streamline" style of automobiles or the bias cut of women's clothing from the 1930s and 1940s, you'll also be talking about styles that can fairly be called "Art Deco."

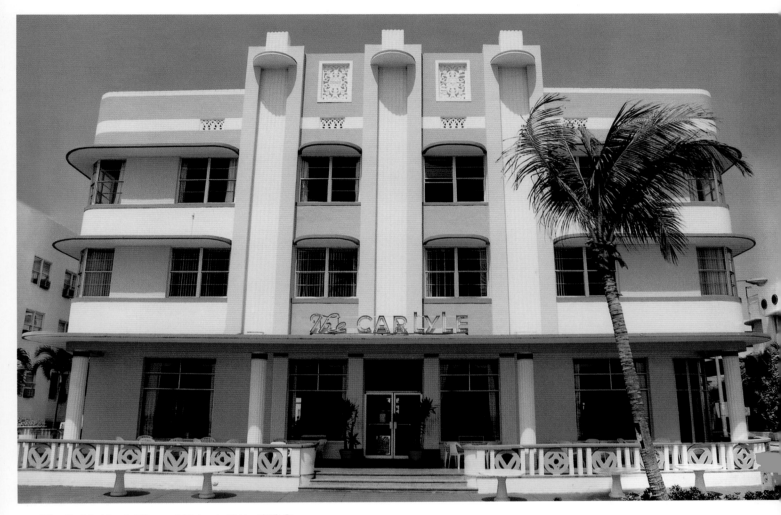

The Carlyle Hotel, Elliot and Kiehnel, 1941. 1250 Ocean Drive…and yes, The Birdcage was filmed here.

4. But "Art Deco," right from its official origination at the Paris Exposition was, and is, much more than one stylistic category. There are, for example "Chinese Deco," "Egyptian Deco," "Mayan Deco," "African Deco," and even "Indian Deco," meaning styles peculiar to the Indian subcontinent of Asia. ➤

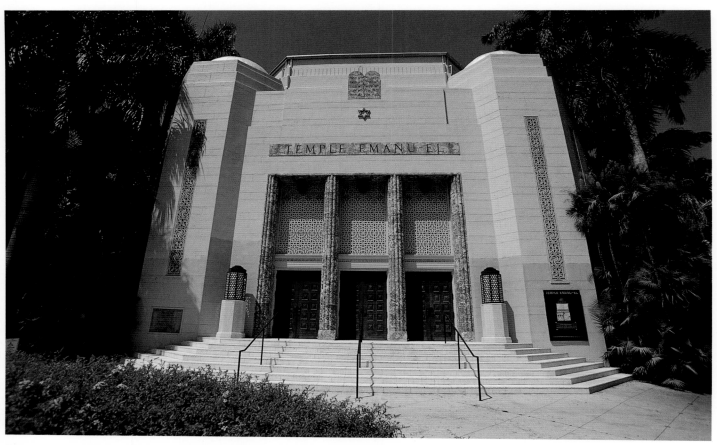

Temple Emanu-el, Anis and Greco, 1947. 1701 Washington Ave. A good example of "Egyptian-Deco."

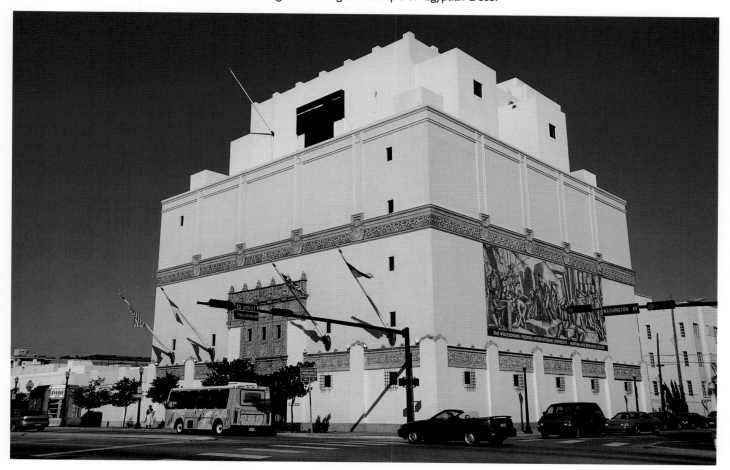

Wolfsonian Museum, Robert Patterson, 1927. 1001 Washington Ave. The flavor here is Egyptian as well.

5. And to make this elastic definition even more elastic, there is the "Fifties Deco" look of, say, fiberglass and chrome furniture, and even a 1950s era architectural style that is technically known as "Miami Modern" or "MiMo," but is also called by some "Fifties Deco." You can see a lot of good MiMo architecture in Miami Beach, where the area of Collins Avenue between 63rd and 87th streets has recently been designated by the City as a MiMo preservation district.

In fact, there is no simple definition of THE "Art Deco" style. Purists may say that it must be a style which originated in the era between the 1925 Paris Exposition and the onset of World War II in 1939. But, even if you accept this restriction, it is not so much a definition or a style as it is a historical period.

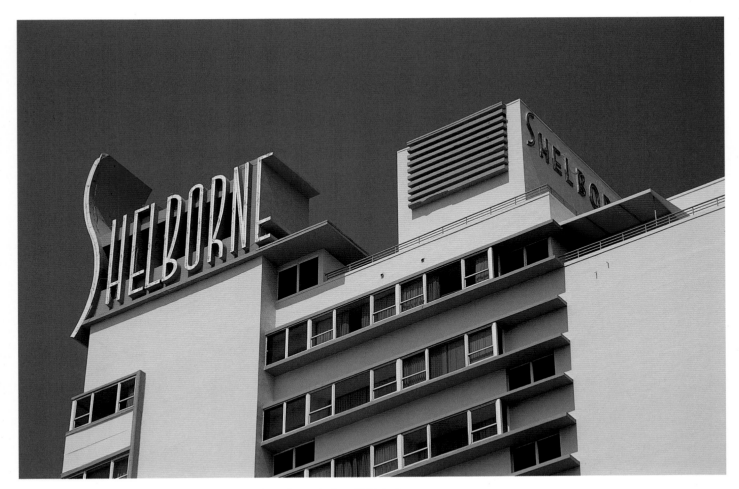

The Shelborne Hotel, often referred to as "fifties Deco," was built in 1954 by Igor Polevitsky. We here in Miami Beach refer to this style as Miami Modern (MiMo).

So, having said all this about Art Deco, here's what I think it essentially is:

Art Deco is a combination of a characteristic "sense of style" (as opposed to a specific style) and the use of "modern" materials (like chrome, plastic, and aluminum) and construction processes which emerged in the period from 1920 to about 1940.

This may not be as specific as you'd like me to be, but remember that we're dealing with objects in this style ranging in size from a miniature "Scottie-dog" brooch to the Empire State Building in New York, ranging in color from the stark black and white finish of a checkerboard-tile floor to the outrageous pastels of South Beach itself; ranging in materials from the cleanliness of stainless steel to the "milkiness" of the bakelite jewelry designs which become more and more prized each year.

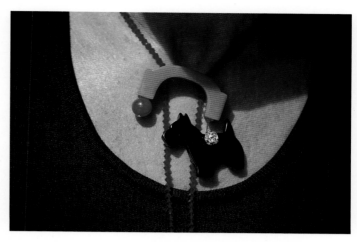

The Scottie was a favorite Art Deco subject of many designers, influenced by FDR's little pooch. This one is made of bakelite, a plastic invented and greatly utilized in the Deco era.

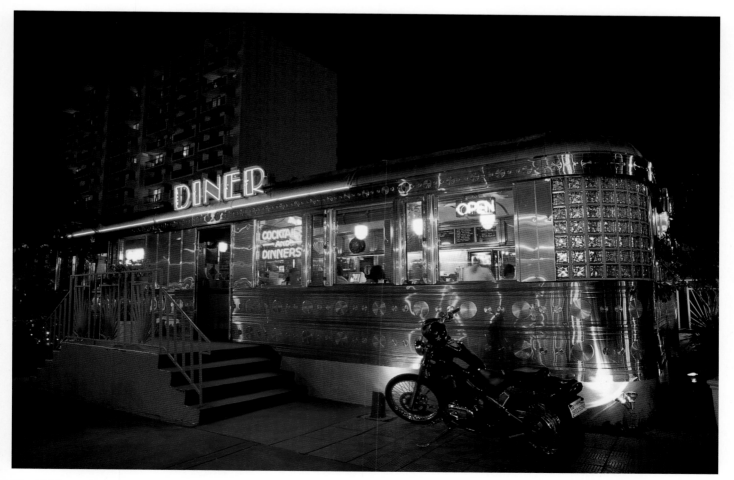

The 11ᵗʰ Street Diner, made of Stainless Steel.

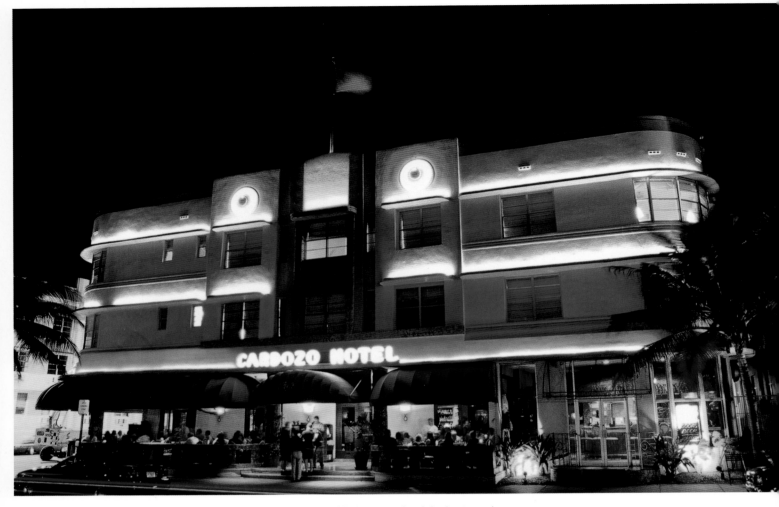

The Cardozo Hotel , 1300 Ocean Drive, Henry Hohauser, 1939. An example of the horizontal, "spread-out" design, allowing a canvas wide enough for many different Art Deco treats: eyebrows, curves, details and, of course, neon. "A Hole In The Head", starring Frank Sinatra, was filmed here in the 1950s.

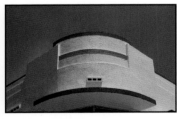

And there's something very important about the shapes that are included in the "Art Deco" sensibility. They are often called "geometric shapes" because they tend to be simpler than the Art Nouveau style which preceded the Art Deco era. But, within this "cleaner" style, you'll find graceful curves as well as sharp angles; and you'll see buildings and other objects that are essentially spread out and "horizontal," at the same time as you see objects with the upward thrusting style of the Chrysler Building in New York.

The "bottom line" about what is, and isn't, "Art Deco?" You can't go wrong if you stay with what was considered "new" during the decade and a half from 1925 to 1940. And you will gain confidence in your own sense of this sense of style as you read books like this one and visit places like South Beach, where so much of a particular branch of Art Deco has been lovingly preserved. Because once you're in Miami Beach, you don't need to take my word for it. You can begin your walking tours and, soon enough, you'll develop your own judgment about what "Art Deco" means to you. I've always thought that if you take definitions too seriously, you'll miss the essence of the Art Deco style, which has a lot more to do with experimental flamboyance and expansive hopefulness than it does with any "rules" about shapes, edges, and materials.

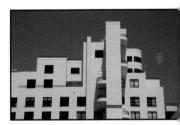

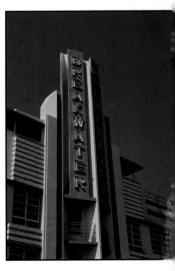

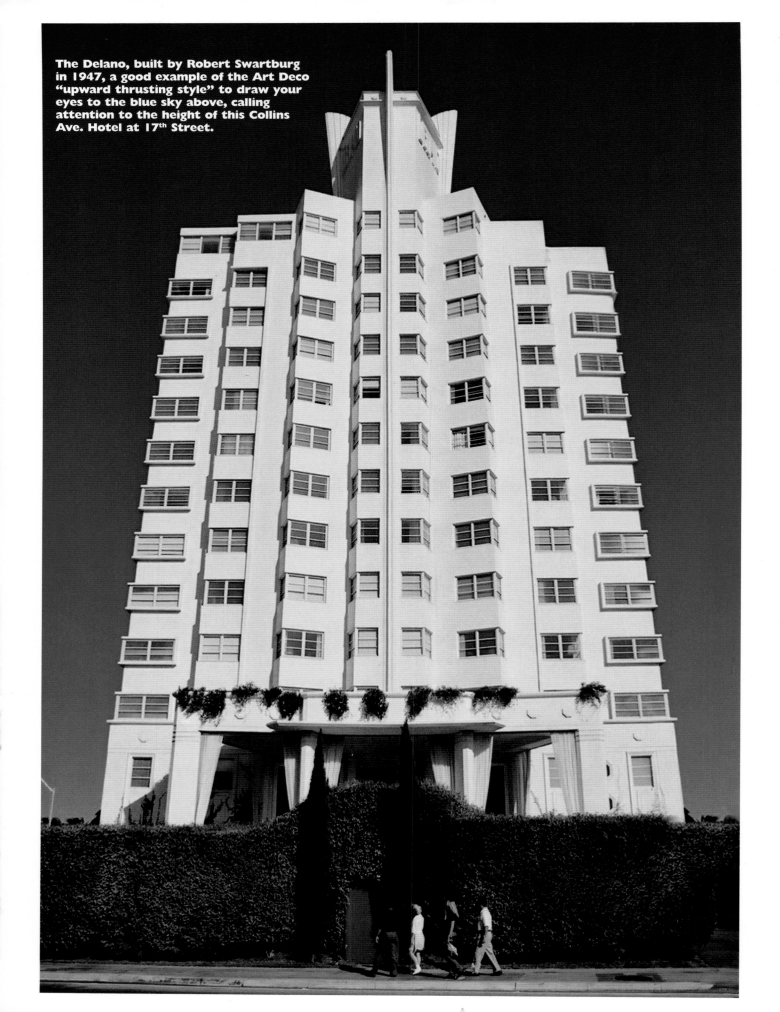

The Delano, built by Robert Swartburg in 1947, a good example of the Art Deco "upward thrusting style" to draw your eyes to the blue sky above, calling attention to the height of this Collins Ave. Hotel at 17th Street.

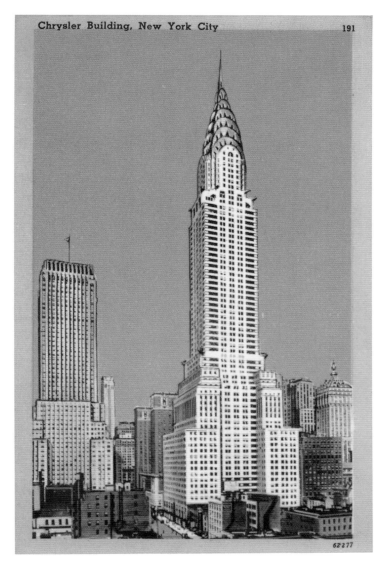

The classic Art Deco example of "upward thrusting style"—New York's Chrysler Building. Postcard, Acacia Card Company.

What About "TROPICAL" Art Deco

(and its kissing cousin, "NAUTICAL" Art Deco)?

This flexible definition of Art Deco as a "sense of style," rather than a narrow style that you could cover fully in one book of photos, is well exemplified in the style of architecture that has made Miami Beach famous as an Art Deco icon. It is usually referred to as "Nautical Art Deco" or "Tropical Art Deco," and it is worlds apart from the urban Art Deco style that is exemplified by the New York City skyscrapers of the 1930s.

Color is a big part of it, of course. Just as the Empire State Building would look, well…silly, in shades of bubblegum and flamingo pink, the Art Deco style in South Beach would be unthinkable without those shades.

The softness of pastel pink is reflected off the Ocean Drive buildings into the morning air, adding a feeling of romance, relaxation, and fun, all at the same time.

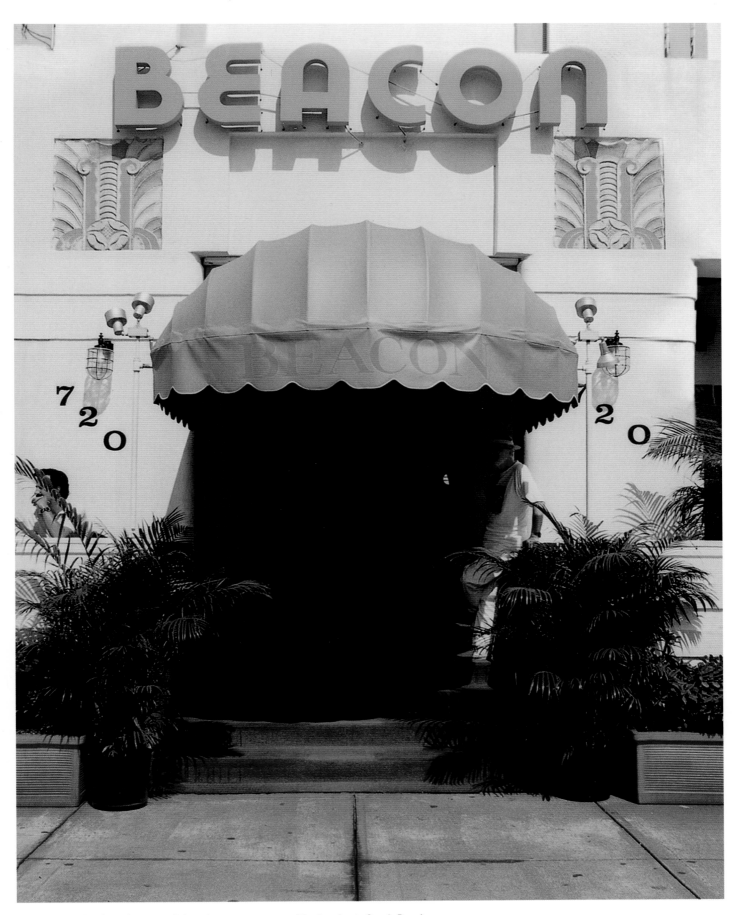

The Beacon Hotel, at the time of this photo, was wrapped in the classic South Beach tropical colors of pink and turquoise. Built in 1936, H. Nelson. 720 Ocean Drive.

It was, in fact, one of the principal founders of the Miami Design Preservation League, Leonard Horowitz, who created a "palette" for the colors that would be considered appropriate for buildings in Miami Beach's Art Deco Historic District. If there were nothing else unique about the architecture of South Beach, these colors alone would qualify it for the special category of "Tropical Art Deco." Unfortunately, it has always been, and remains, a local political struggle to maintain the integrity of Leonard Horowitz's color palette. But there is still a burst of pastel that hits your eyes on the average South Beach street compared to, say, a New England town or a "serious" city in the Midwest. It is as if a roll of saucer-shaped "Necco Wafer" candies had leaped out of its wrapper and formed itself into spaces to live in. As more than one other observer has noted, the District, particularly along Ocean Drive where you can see all the buildings clearly from across the street, looks as if it is made up of frothy "wedding cakes." Some of these cakes are complete with frosted tops placed by a giant hand. Frosting flavors include everything from gleaming pure white through all the pinks and turquoise shades you can imagine, and beyond. What all of these colors have in common, though, is a sense of humor as well as style, and self-confidence in the role of Miami Beach as a place you can proudly come to "just to have fun."

A close-up of the detailing and tropical hues of The Carlyle Hotel.

Art Deco detailing enhanced by tropical colors.

The beauty of design brought out with the beauty of color on this building located at 260 Washington Ave.

Another example of a building relief that takes the stage with the help of contrasting colors…fun to find on so many of South Beach's buildings!

The pastel-accented coloration of South Beach architecture is, of course, eminently sensible in light of the climate. Remember that almost all of the important buildings in the District were built before World War II, when air conditioning was a luxury unknown to all but the super-wealthy. In a situation like that, it only made sense for architects to work in colors which would reflect the intense sunlight away from the building surfaces, rather than absorb the energy of the sun into the interior of the buildings. Just as you would wear white or light color clothing on the hottest summer day, the buildings of South Beach "wear" light colors under the occasionally blazing subtropical sun. So, even in the midst of a cascade of whimsical architectural detailing (more about that later in this book), the architects who built South Beach kept one unblinking eye on the practicalities of the place in which they worked. ᐯ

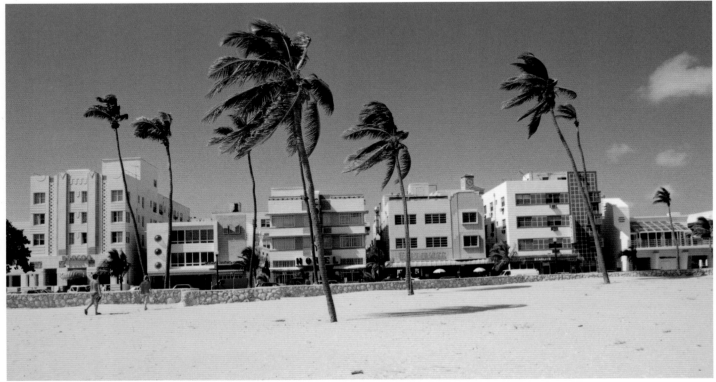

Looking from the beach, Ocean Drive buildings look almost edible in their "necco wafer" pastel shades.

You can also see this concern for climate in another feature of South Beach architecture. You may notice, as you wander around the District or take one of the walking tours, that there are a lot of corners in many of the buildings. Rather than just turn a corner once, for example, buildings like the Shelborne Hotel, the Delano, and the Marseilles, have a series of corners that move back from one direction to another and finally result in a right angle at the last of the mini-corners. Why so many corners? Well, each corner creates the opportunity for a wall, and each wall creates an opportunity for a window. If you are on a corner, you can have windows in both directions, and windows let in not just light, but also air. If you're building in a hot place before the advent of air conditioning, two directions of air-flow is a very valuable thing, otherwise known as cross-ventilation. Particularly if you have the (relatively cool) Atlantic Ocean on one side and a slightly less cool air mass on the other, the difference in air temperature may actually give you a private breeze of sorts in your two-directional space, whether it's a year-round apartment or a one-night hotel room. While it was never as good as air-conditioning, this sort of clever building design made a lot of difference to people in the Art Deco years.

An entranceway to a very ornate (Aztec Deco) building on Fifth St. between Euclid and Meridian Avenues — a jubilee of details and colors...the details remain the same — the colors always changing...but always yummy!

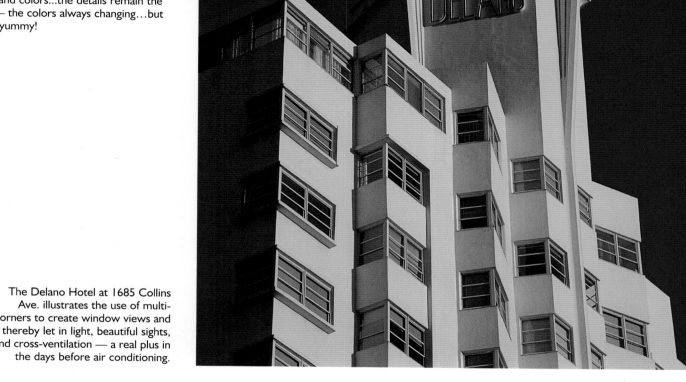

The Delano Hotel at 1685 Collins Ave. illustrates the use of multi-corners to create window views and thereby let in light, beautiful sights, and cross-ventilation — a real plus in the days before air conditioning.

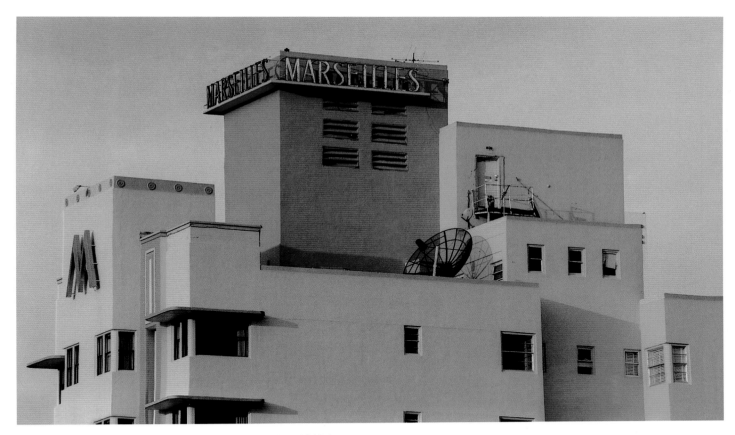

The Marseilles Hotel, another Swartburg creation, built in 1948, has many corners, many windows allowing for cross-ventilation and wide "eyebrows," another of the features which were added not only for artistic detailing, but to provide protection from the summer heat.

But let's remember that we are talking about an architectural style that could also, at its best, be strikingly whimsical, if not quite impractical. Some of the shapes (architecturally speaking) you'll see in South Beach look as if they belong more appropriately on the sea than near the sea. It is this sort of shape that gave birth to the phrase "nautical Art Deco architecture." One aspect of the Art Deco era that has yet to be duplicated was its fascination with the design and comfort features of mass transportation. The most storied of all these transportation vehicles was the transatlantic ocean liner. This fascination was not lost on the architects and designers who shaped some of South Beach's finest buildings. Among them

are the east-facing (i.e., beach-front) facade of the building which houses the Art Deco Welcome Center and still functions as Miami Beach's Beach Patrol Headquarters, the Cardozo Hotel at 1300 Ocean Drive, the McAlpin at 1424 Ocean Drive, and the Victor Hotel at 12th and Ocean (under renovation at this writing).

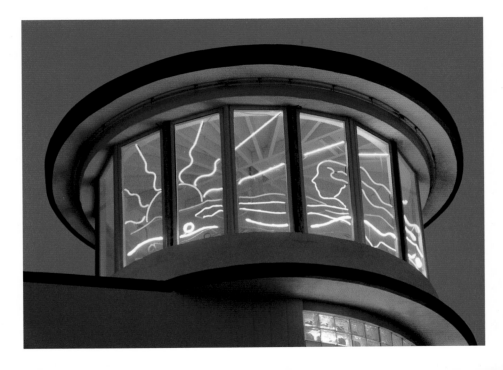

The Waldorf's tower mimics a "crow's nest" on a ship. The artistic modern neon inside screams "vacation"!

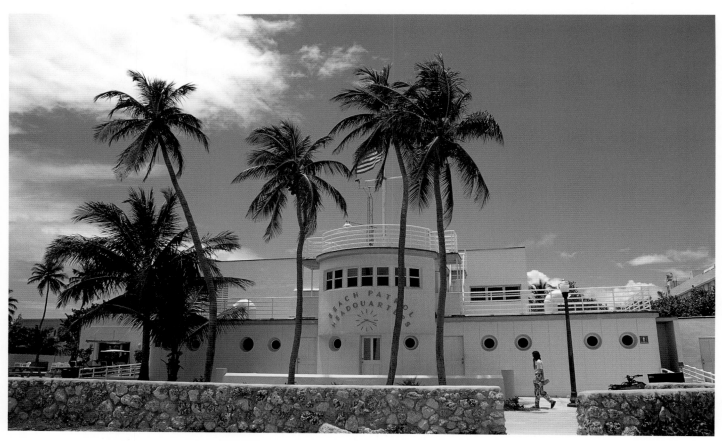

The Beach Patrol Headquarters, another 1930s Art Deco ship-like building, is a perfect example of nautical Art Deco styling. It looks like it has been washed up to shore. The Art Deco Welcome Center's entrance is behind this building (on the non-beach side).

The McAlpin, built in 1940 by L. Murray Dixon, has its nautical details lit up in neon. 1424 Ocean Drive.

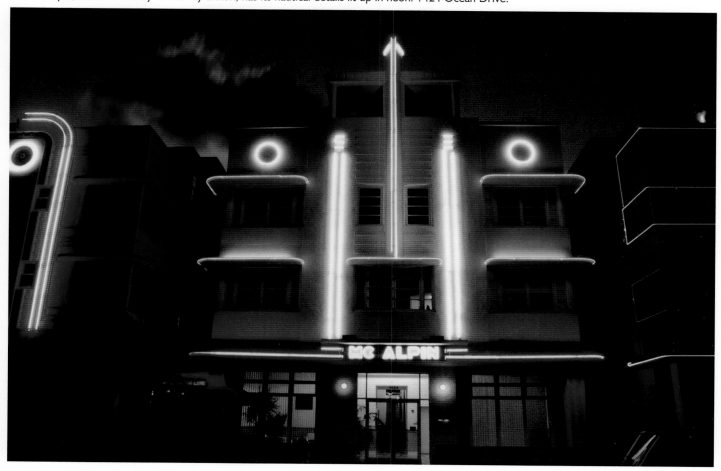

The common element in all these structures is that they look like (or, at least, echo the shapes of) ships at sea. You may see a prow here and a stern there, a mast thrusting up from a courtyard, a row of portholes or a crow's nest (a LIGHTED crow's nest, in the case of the Waldorf Towers Hotel at 860 Ocean Drive) nestled into a hotel roof. These nautical shapes may have been, in some cases, the embodiment of Depression-era yearnings for the romance and escapism of the sea. In others, they may have been a sly commentary on the notion of the building-as-stage-prop. Whatever the combination of motives and dreams, the collection of nautical Art Deco buildings in South Beach is probably unrivaled in any other corner of the world.

So it isn't "just" Art Deco that you can see in South Beach as in no other environment, but also the particular subset of Art Deco that has come to be known as "nautical Art Deco" or "tropical Art Deco."

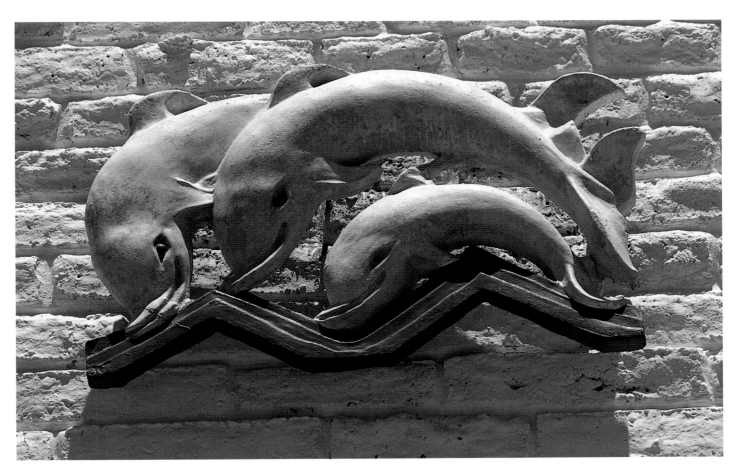

Even apartment building walls carry nautical figures. You'll discover many during your walks.

Chapter Five
Where to Start?

Since even the Historic District encompasses several neighborhoods; and "Art Deco" means so many different things to different people; and there are SO many different kinds of people here, where are you supposed to start your tour of South Beach, this delicious result of what Art Deco and the natural environment have done for one another?

Well, just the other day a friend was standing in front of the building where I work, and he referred to its location as "the corner of Main and Main." And my husband, when he tells people about where I work, calls it "The Center of the Universe." Of course, geographically, it couldn't be much FARTHER from "central," since you can't even walk or drive EAST…and if you do, you'll end up in the Ocean. I'm referring to the Art Deco Welcome Center at 10th Street and Ocean Drive in South Beach, USA.

So that is where you should start your journey into the most fascinating square mile of purpose-specific architecture in the world.

If you're like most visitors to Miami and Miami Beach, you won't be able to walk very far from your starting point at 10th Street and Ocean Drive without noticing that unmistakable aroma of brewed coffee. And, within a few blocks of home base, you'll find coffee and ambience to suit every whim and soothe every hangover. Going west one block and north one block more from 10th and Ocean, you'll see a small crowd of eager-looking, sometimes bedraggled customers at "David's Café" (11th and Collins Avenue). This is one of the slowly disappearing (but, one hopes, never to be extinct) *Café Cubano* specialty shops here. Like most of these characteristically Miamian places, there is an indoor-outdoor counter area around which the

The Ocean Drive street sign means you're as close to the beach as you can be without being on it.

David's, at 11th Street and Collins Avenue, serves up the famous café cubano. Try a cortadito if you like milk…or a café con leche if you like lots of milk.

true addict of this Caribbean jet-fuel will gather each and every day. The good news about this institution of the café cubano kiosk is that they are usually genuinely Cuban and almost always take pride in serving the highest quality syrupy-sweet brew they can make. And the next part of the good news is that at a place like David's (remember, we're only a block from our starting point and we're already having a party) you can get a basic *cortadito* (which translates as: "a little short one") for less than a dollar – ninety-five cents to be exact. The slightly less basic, but still rich and delicious *café con leche* (which is a *cortadito* with some very rich dairy in it) is yours for only $1.25.

At the other end of the coffee-shop scale is the Ocean Drive Starbucks in the Il Villagio building, just below 15th Street on the east side. While not as close to your starting point – and not as close to the Hispanic side of the South Beach soul – this Starbucks of course offers all of the chain's usual treats. For those of you who are not already Starbucks addicts, this is a good place to start. You can smell the coffee and the sea in the same breath. You can banish the grogginess of the previous night's festivities, wake yourself up and smell the coffee, and still have plenty of time to wander onto the beach and finish the wake-up process with a dip in the turquoise Atlantic. Not a bad set of experiences for an early morning in South Beach.

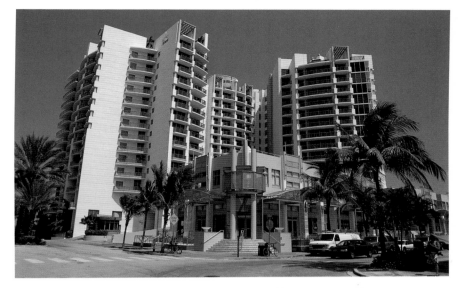

The Shops at Il Villagio include a Starbucks, of course. Have a seat outside where you can see the sea while sipping on your café of choice.

Then again, if you want to visit the "New York" side of South Beach – and get a dose of beautifully restored Art Deco architecture at the same time – you should visit Jerry's Deli at Collins and Espanola Way (Espanola Way is one of the few South Beach streets that doesn't use a number for its name, but it's basically 14.5th street). Jerry's, like Starbucks, is less than a five-block walk north (and for Jerry's, one block west) from your starting point. Unlike Starbucks, it is in a building that screams Art Deco. You can sit indoors or out, but if you sit inside, you will be rewarded with a very nicely restored Art Deco interior design while you sip on your "cup o' joe."

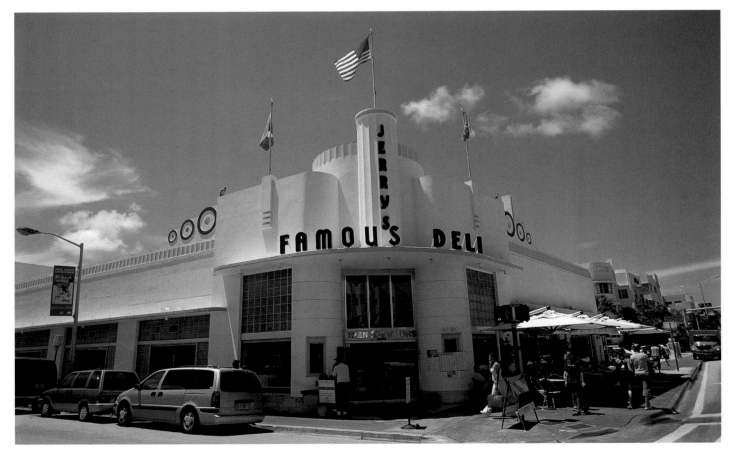

Jerry's Famous Deli at 1450 Collins was built in 1940 by Henry Hohauser. Its present use as a deli is the closest it has come to its original use as Hoffman's Cafeteria — good food at reasonable prices. In between it has been a ballroom, a disco, and a gay club. The coffee here is as good as a New York City coffee shop's.

Chapter Six

A Walk Down (or Up) Ocean Drive

The Avenue of Dreams

Before we can send you on some of the more unusual walking tours in this book, we need to cover the basics. And nothing is more basic than the iconic parade of small, mostly Art Deco, hotels on Ocean Drive itself. Ocean Drive, as you may already know, is only fifteen blocks long – running from the southern tip of the Island called "Miami Beach" up to 15ᵗʰ Street, where it turns west and more or less merges into Collins Avenue. From your starting point at 10ᵗʰ Street and Ocean Drive, your Ocean Drive walking tour could take you north to 15ᵗʰ Street, south to Fifth Street (more about the "South-of-Fifth," or "SoFi," area coming up), or on a meandering random route which is more like the anything-goes atmosphere of which South Beach natives are so proud. Even though this book would be the last to preach a "disciplined" tour of South Beach, we'll survey the outstanding Ocean Drive hotels with 10ᵗʰ and Ocean as our starting point, more or less as you might encounter them as you would walk south from 10ᵗʰ and Ocean or up Ocean Drive to 15ᵗʰ Street.

From the Art Deco Center Toward the South:

1001 Ocean Drive is the only habitable structure on the east side of Ocean Drive anywhere between 5ᵗʰ and 14ᵗʰ Streets. Among other things, it houses the Art Deco Welcome Center, which I recommend be your jumping-off point for many of the walking tours in this book. This same structure also houses the offices of the Miami Design Preservation League, the organization most responsible for the inspiration of the South Beach renaissance. While the facade that you can see from Ocean Drive is rather Spartan and plain (some have, frankly, called it ugly), the façade of the other side of this same building is a terrific example of the "Nautical Art Deco" genre that is, perhaps, South Beach's most characteristic style. You need to go around to the oceanfront side of 1001 Ocean Drive and view the Beach Patrol Headquarters façade from that angle. You'll be rewarded with what appears to be a cross between a landed building and the stern of a multi-deck ocean liner from the 1930s, complete with portholes and a mast-like flag standard.

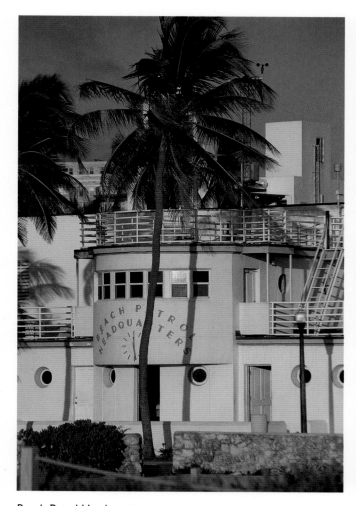

Beach Patrol Headquarters.

One of the features of the Beach Patrol Headquarters that says a lot about Miami Beach in general is that it offers special sand-worthy wheelchairs for those who need that kind of equipment in order to enjoy the beach safely (no charge).

Miami Beach's beaches are wheel-chair accessible.

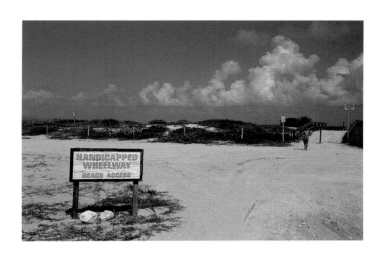

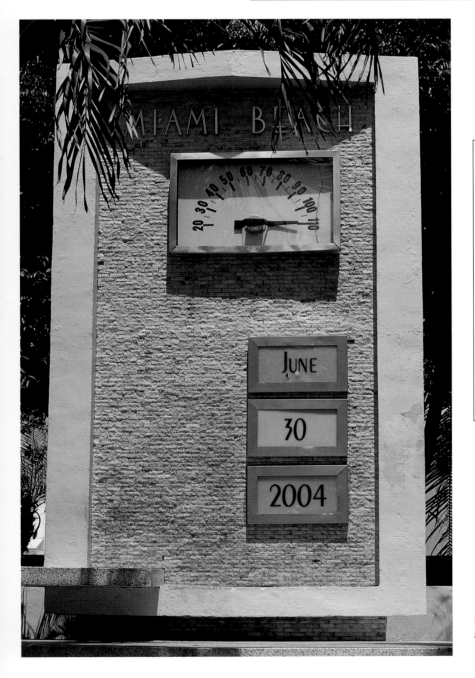

And it wouldn't be right to depart from the east side of Ocean Drive's 1000 block without noting the famous calendar and date display just to the south of the Art Deco Welcome Center. This spot may be more important to you than you think. It is where a LOT of honeymooner types from the north have had their photos taken, so that the thermometer reading could convince their friends back home that they really WERE in 80-degree weather in their swimsuits during the middle of January. If your parents or grand-parents ever vacationed in Miami Beach, there's a good chance that they had a photo taken here.

Famous Temperature Structure on Ocean between 10th and 11th streets. It is rare for Miami temperature to reach 100°. Perhaps the dial will be fixed by the time you visit.

The 900 block boasts two side-by-side, relatively large hotels. The Breakwater, built in 1939 at 940 Ocean Drive, is noteworthy both for its massive porch, about twenty feet deep and running the building's entire width, and its vigorously up-thrusting central sign standard, neon-lit after dark. The porch has hosted a number of good and not-so-good restaurants, which have been consistent mostly in the music and energy that they bring to this part of Ocean Drive. You might think from looking at the Breakwater's neighbor, the Edison, that the two buildings had been constructed in completely different time-frames. In actuality, however, the Edison was built in 1935, smack in the midst of Ocean Drive's Depression-era building boom, and the Breakwater only four years later. While the Breakwater is surely an example of Tropical Art Deco architecture, the Edison, in contrast, draws its inspiration from the Mediterranean Revival style that is South Beach's "secondary style," so to speak. Situated at the corner of Tenth and Ocean (right across from the Art Deco Welcome Center, the center of the "South Beach Universe"), the Edison marks the traditional mid-point of the parade of Ocean Drive architecture, a good time to take a break and have an alfresco mid-day meal.

If you're at the Edison for more than just a quick drink, by the way, I recommend that you spend a few minutes checking out the "Miami Beach During World War II" exhibit that, as of this writing, has been permanently established at the Edison. This is a fascinating tale about Miami Beach turning its famous hotels into bunks for GIs in training, hundreds of them taking calisthenics on the broad white-sand beach, and many of them seeing palm trees for the first time. It was this experience during the 1940s, in fact, that led to a lot of the area's growth after World War II. Many of the boys (and some girls) who trained here never shook off their fascination with sand in their shoes and ocean breezes in their hair. They returned here with families and became permanent residents after the war was over, and a whole lot more remembered it as a place that they would like to see again as a carefree vacation spot.

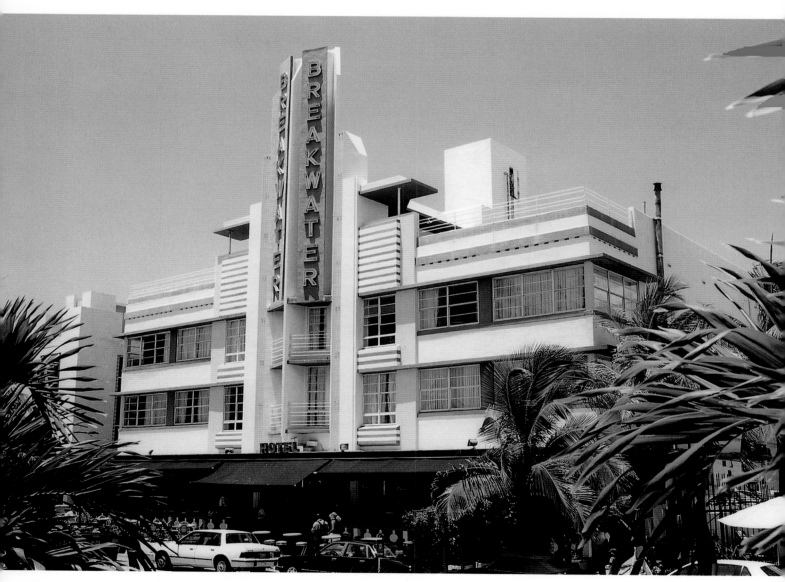

Breakwater Hotel, Anton Skislewicz, 1939, 940 Ocean Drive.

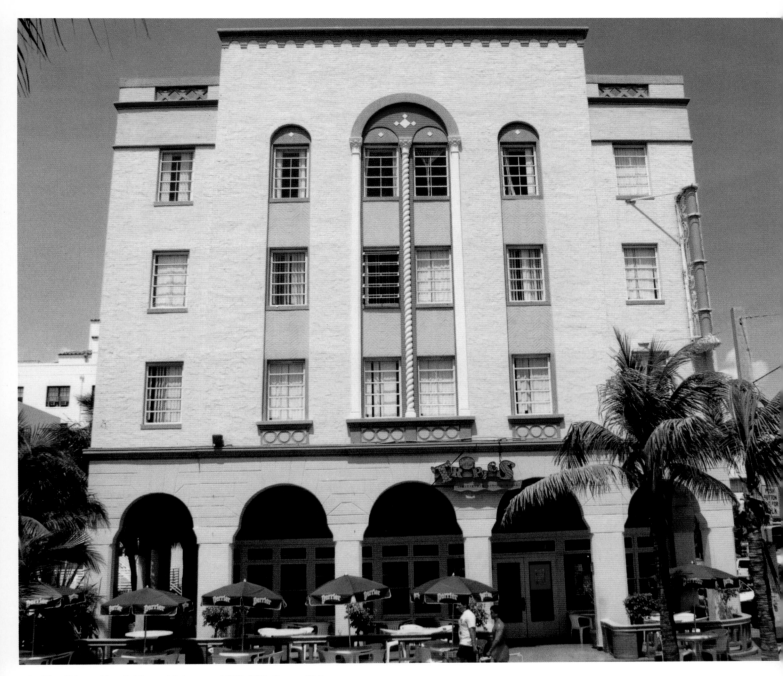

The Edison Hotel, Henry Hohauser, 1935, 960 Ocean Drive.

The outstanding sight on the 800 block of Ocean Drive is the Waldorf Towers, built in 1937 at 860 Ocean. Sweeping around the corner of Ninth Street, the structure subsumes many of the most telling elements of the tropical Art Deco style. The most notable single feature of the Waldorf Towers is its neon-lit cylindrical tower (again, only four stories up, but nevertheless a "tower" in the company of its neighbors) which was actually recreated in 1985 at the beginning of South Beach's Art Deco renaissance. Further down this same block is the News Café. You really shouldn't miss having brunch or lunch at the News Café (800 Ocean), famous as a hangout for fashion models and the place where the fashion designer Gianni Versace ate his last breakfast in 1997.

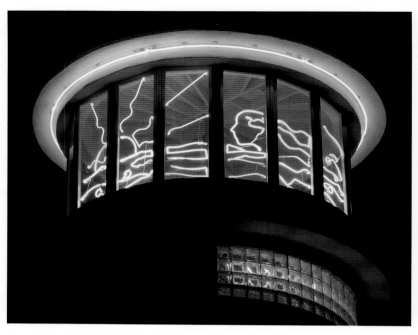

Neon lit tower of the Waldorf Towers Hotel.

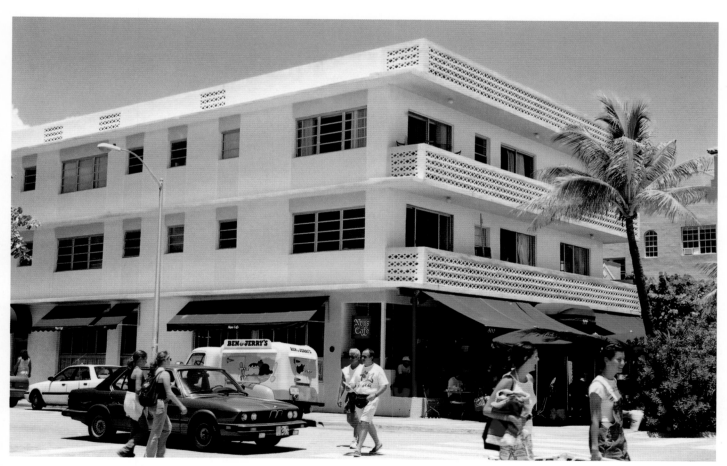

News Café, corner of Ocean Drive and 8ᵗʰ street.

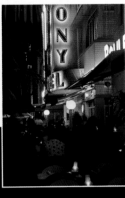

A half century before the 1985 restoration of the Waldorf Towers "crow's nest," Ocean Drive saw the building of the Colony Hotel, at 736 Ocean. Built in 1935 (with the original façade having been "replicated" early in the current South Beach renaissance), the Colony is one of the most photographed hotels on the strip because of its oversized, very neon, vertical hotel sign which is typically illuminated in a garish, but oh-so-South-Beach, lavender/blue. This is obviously at its best as an after-dark sight. Next to the Colony (at 720) is the Beacon Hotel, completed a year after the Colony and boasting a south-extending addition to the usual "Rule of Three" vertical "tower." In keeping with the small, human scale of (most) Ocean Drive hotels, this tower is only four stories high. At the south end of the 700 block sits the Avalon Hotel, built in 1941 as the St. Charles.

Colony Hotel, Henry Hohauser, 1935, 736 Ocean Drive.

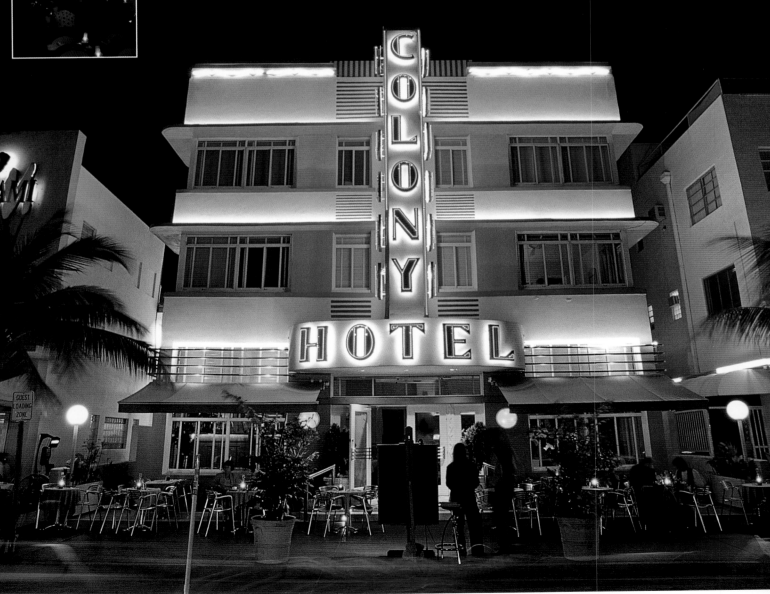

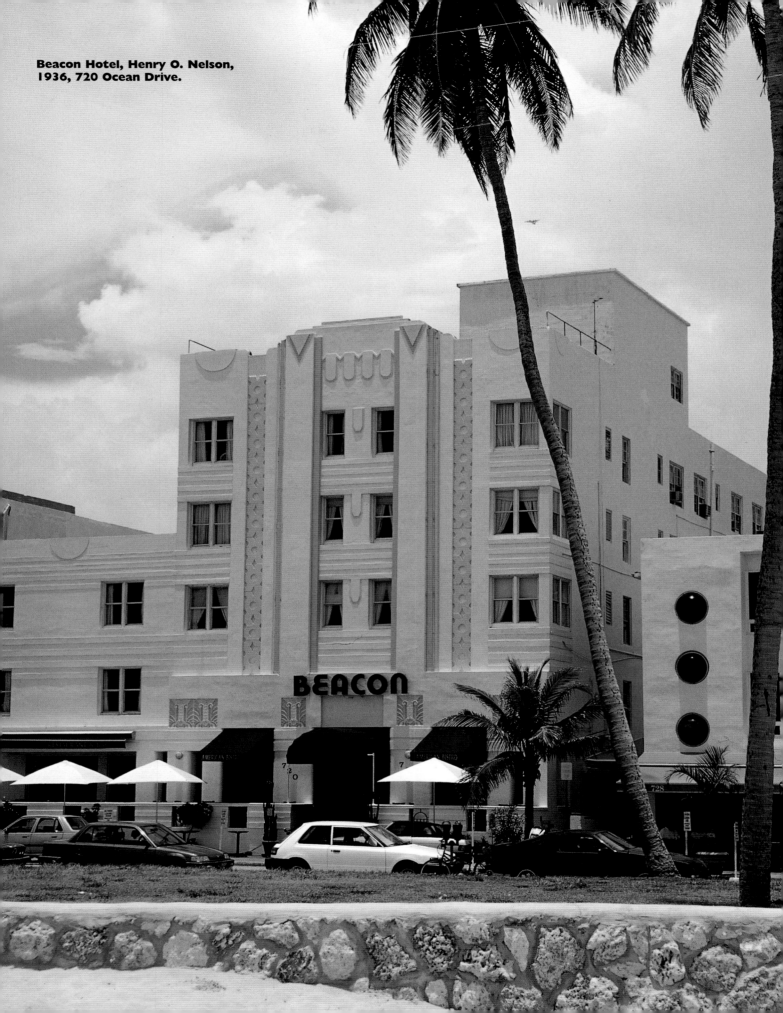

Beacon Hotel, Henry O. Nelson, 1936, 720 Ocean Drive.

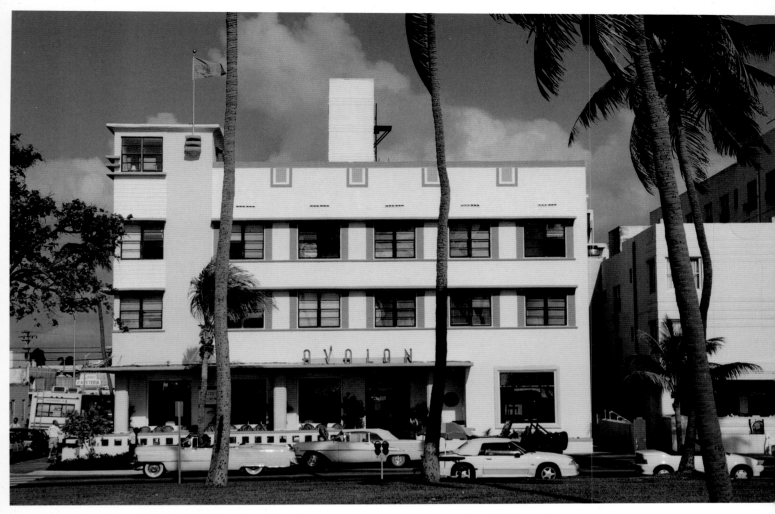

Avalon Hotel, Albert Anis, 1941, 700 Ocean Drive.

Looking south from 7th St. and Ocean Drive.

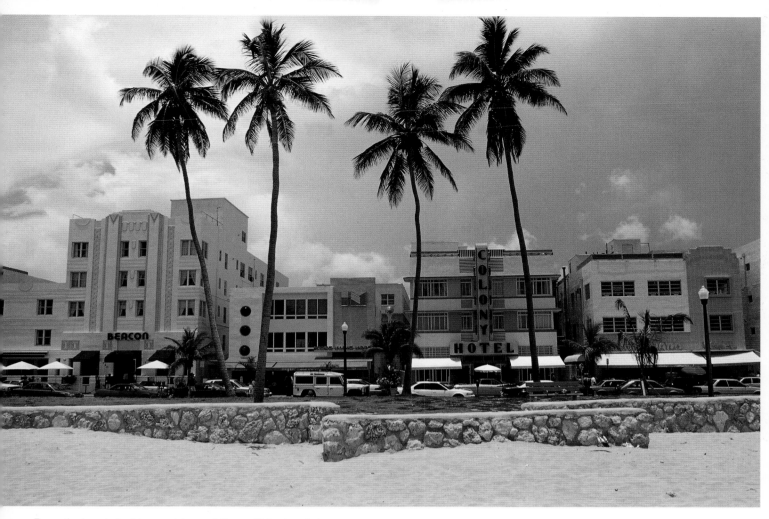

From the beach, looking west toward Ocean Drive hotel clusters.

North of these Art Deco treasures, at the southwest corner of Eighth Street, sits a bar and restaurant called "Wet Willie's." While this establishment may have its faults in other areas (you can be the judge of that), it is unparalleled in that its second-floor area affords the best view of the sandy beach from any restaurant along the strip. For some reason, Ocean Drive hoteliers have never established their main restaurant spaces on any floor above street level. Wet Willie's is the exception, a place where you can eat and "see the sea" at the same time.

Wet Willie's, where you can sip on a "sex at the beach" and see the beach from the 2nd floor eatery. At 760 Ocean Drive.

The 600 block is the actual southern starting point for the federally designated Historic District. So it is a good thing that it also boasts some of the era's finest architectural statements. The Park Central Hotel at 640 Ocean was built in 1937 and is, at seven stories, among the tallest of Ocean Drive's "wedding cake" buildings (some have more icing than others...you'll see what I mean). The façade of the building is itself a medley of classic Art Deco elements, ranging from its tripartite upward thrust to its full-width porch.

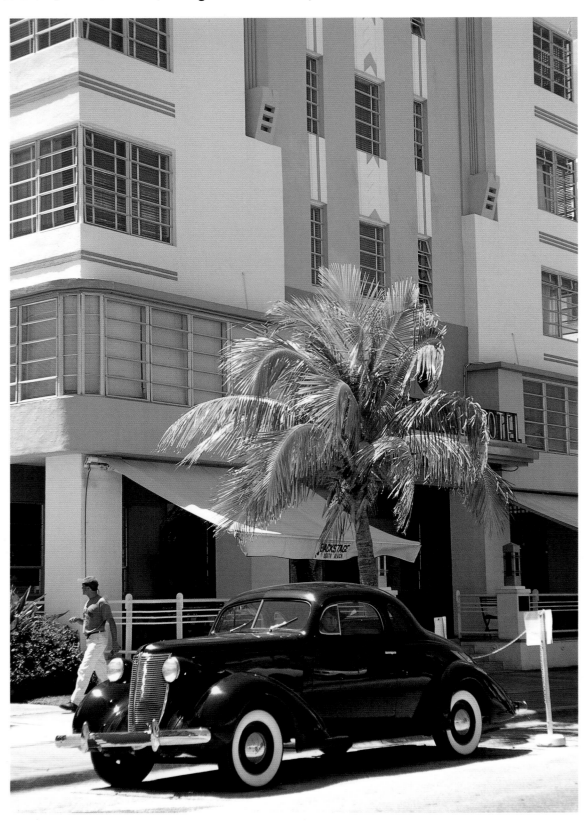

Park Central Hotel, Henry Hohauser, 1938, 640 Ocean Drive.

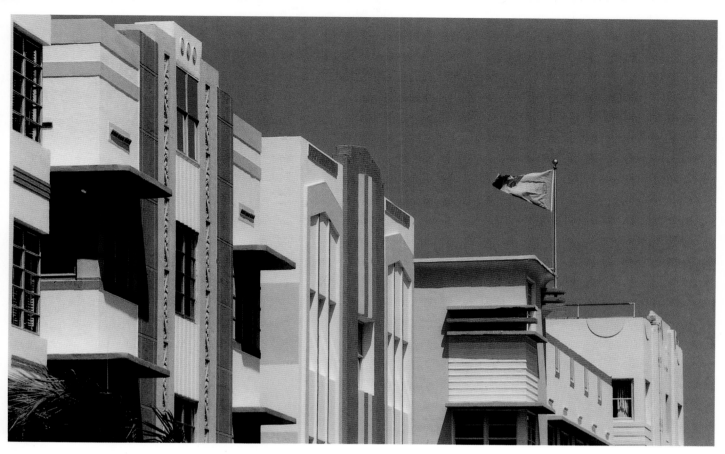

Hotels on the Drive, each one complementing its neighbor.

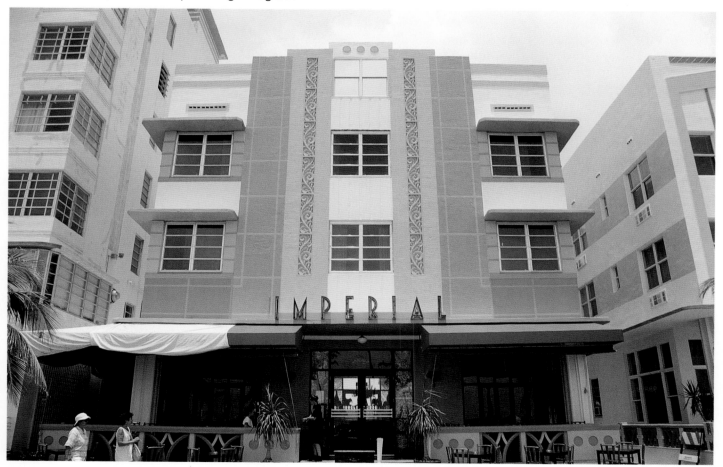

Imperial Hotel, L. Murray Dixon, 1939, 650 Ocean Drive.

Speaking of porches, you will note during your stroll along Ocean Drive that almost all of the buildings do have porches and/or patios jutting out from the main building structure toward the street. These areas have proven to be the most popular spots for drinking, dining, and enjoying the weather during the South Beach high season, which is generally considered to start in December and end in April.

The Park Central is also noteworthy because it was built with more of a sense of ocean-resort spaciousness than some of its smaller neighbors. One of these smaller neighbors is the Imperial, at 650 Ocean, which has unusually deep window eyebrows and repeats the "Rule of Three" in its exterior façade.

From the Art Deco Center Toward the North:

On the west side of Ocean Drive, just north of 10th Street, you'll find the raucously entertaining Clevelander Hotel, which was founded in the late 1930s, sensibly enough by a family from Cleveland. A signature structure within the Clevelander's relatively large lot is a flying-saucer type sculpture that shades one of the many linear feet of liquor bars snaking through the property. Covering nearly the entire remainder of the 1000 block is a renovation project on the Adrian Hotel, which is actually a collection of several 1930s (and one 1950s) buildings being consolidated into one property. Within the Adrian, there are examples of everything from the portholes so characteristic of Nautical Art Deco to Mediterranean Revival. A smorgasbord of South Beach styles still (at this writing) under hopeful renovation.

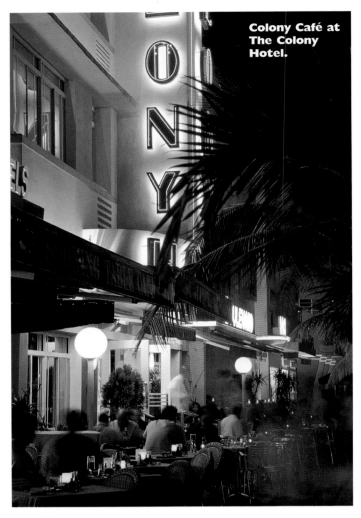

Colony Café at The Colony Hotel.

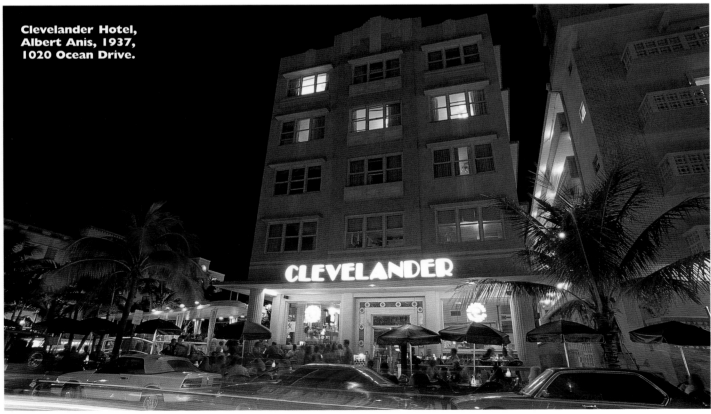

Clevelander Hotel, Albert Anis, 1937, 1020 Ocean Drive.

The 1100 block includes at least two structures that are worthy of extended consideration. One is the Casa Casuarina at 1114, a fine Mediterranean Revival building which was built in 1930 and was called the Amsterdam Palace (after its owner's last name) from 1935 onward until purchased by the fashion designer Gianni Versace in 1992. Casa Casuarina, as discussed elsewhere in this book, has now become famous as Versace's South Beach mansion and the structure on whose front steps he was murdered by a deranged drifter in 1997. Note, among the delightfully eclectic architectural details, the dome of the private observatory that is part of the "skyline" of the building. At the northern end of this 1100 block sits another important current (as of this writing) renovation, the Victor Hotel. This unusually massive hotel (for Ocean Drive, anyway) was built in 1937, another example of the specific Nautical Art Deco style that is synonymous with South Beach. The Victor sports porthole-like windows as well as a northern façade which recalls the shapes of an oceangoing liner. If the renovations have been completed by the time you read this book and visit South Beach, the Victor is definitely worth a look.

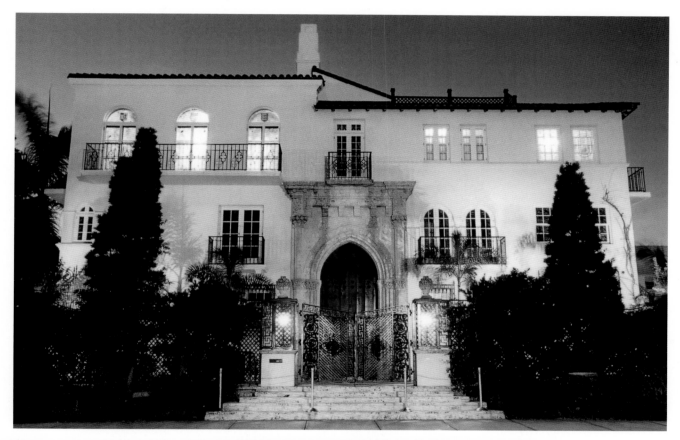

The Versace Mansion, formerly The Amsterdam Palace, formerly Casa Casuarina (and, at this writing, Casa Casuarina once again).

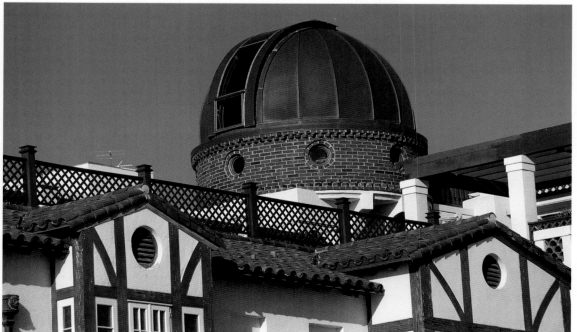

The domed observatory designed for Versace's Mansion

There are many sights to see in the 1200 block, where the soaring Tides Hotel, the gemlike Leslie, and the more-wedding-cake-than-thou Carlyle Hotel all reside. Built in 1936, the Tides is an anomaly on Ocean Drive. It is big, even by the standards that we would apply in an ordinary American environment. For starters, it is twelve stories in height. Most everything else along Ocean Drive, as you have no doubt concluded by now, is three or four stories. The Tides also enjoys a double or triple helping of Ocean Drive frontage, with gracious, wide steps sweeping you up to its central doorway. Just up the street is the classically Art Deco Leslie Hotel, perhaps the essence of the simplicity and cleanness of the style in general.

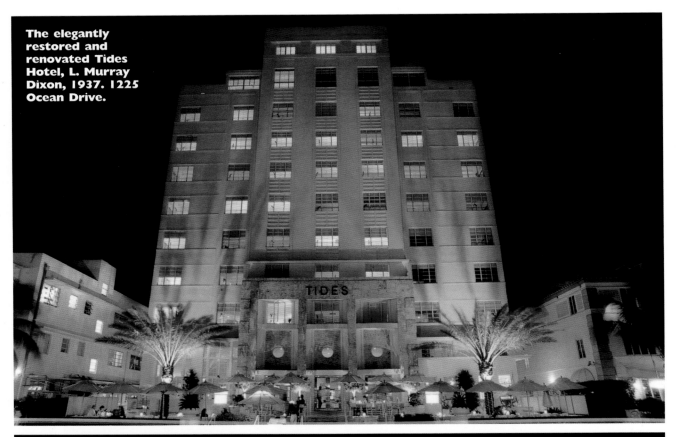

The elegantly restored and renovated Tides Hotel, L. Murray Dixon, 1937. 1225 Ocean Drive.

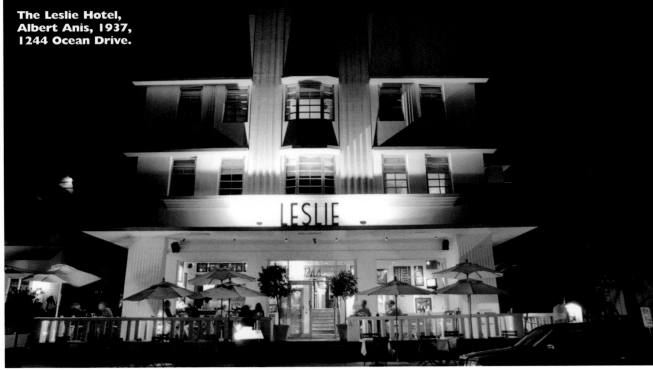

The Leslie Hotel, Albert Anis, 1937, 1244 Ocean Drive.

To the north of the Leslie is the Carlyle (see photo on page 18) at 1250 Ocean. Here is a building that displays many of the themes that have made South Beach the Art Deco capital of the world. It is both assertively vertical and aggressively horizontal at the same time, with three (so often it is three in the Art Deco architectural style) thrusting elements bursting through its roofline – which itself has three roof-top elements. There are also eyebrows over its windows which carry the structure around the corners at both ends. The Carlyle was one of the locales for principal cinematography of the film "Birdcage" during the mid-1990s.

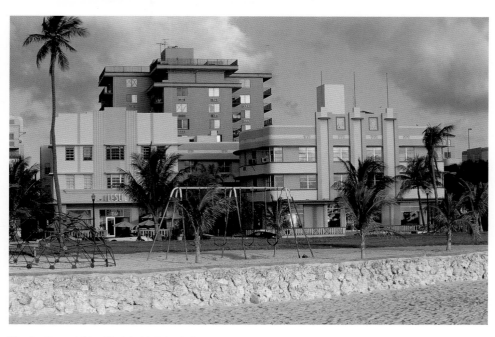

The Leslie and The Carlyle Hotels at dawn.

Many of these themes are continued in the Cardozo Hotel (see photo on page 22), which sits at 1300 Ocean Drive and features a sweeping front porch that curves gracefully around the corner onto 13th Street. Built in 1939, it is generally considered a masterpiece of the streamline style.

The ornamentation on the nearby Cavalier Hotel, at 1320 Ocean, provides an example of the "Egyptian-Deco" and "Mayan -Deco" themes which informed the basic Art Deco style during the 1930s.

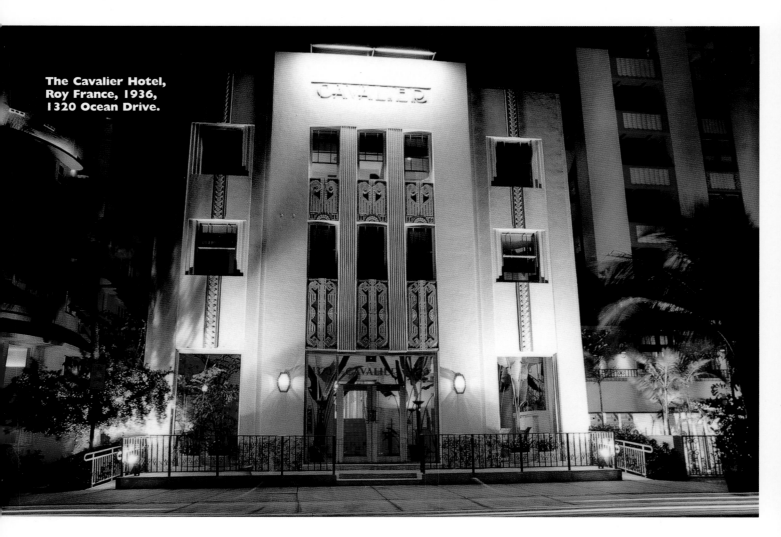

The Cavalier Hotel, Roy France, 1936, 1320 Ocean Drive.

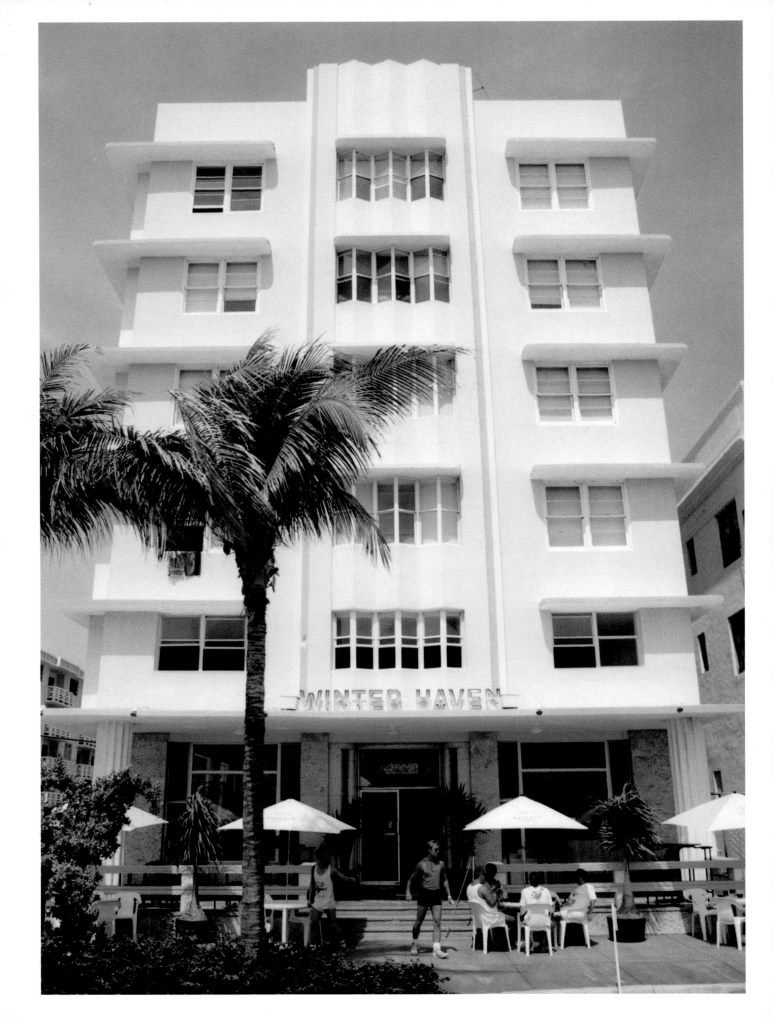

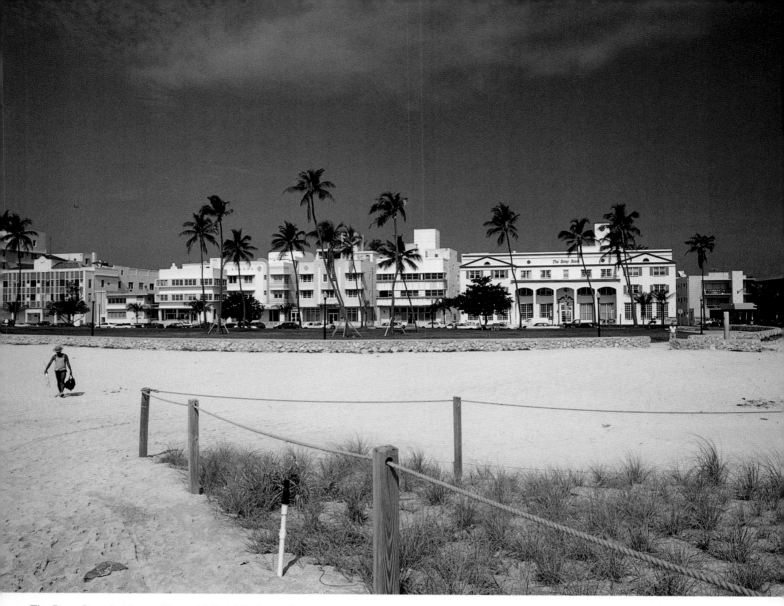

The Betsy Ross, L. Murray Dixon, 1941, 1440 Ocean Drive.

The Art Deco integrity of the Carlyle and Cardozo are echoed in the 1400 block, starting with the Winter Haven at 14th and Ocean, where the lobby interior has also been restored to its original state, and the Crescent at 1420, which adds nautical elements to the streamline theme. The Crescent sits right next door to the Penguin Hotel at 1418 Ocean. The Penguin's great claim to fame is its Front Porch Café, a place where you can eat a dependably excellent "family-style" meal right in the lap of the Atlantic and still have some money in your pocket after you've finished dessert. Also noteworthy in the 1400 block are the McAlpin (see photo on page 31), right next door to the Crescent and the Betsy Ross. Though usually not emphasized in the guidebooks, because it is neither Art Deco nor Mediterranean Revival, the Betsy Ross shouldn't be missed, if for no other reason than its demonstration that, in South Beach, anything goes.

◄
Winter Haven Hotel,
Albert Anis, 1939,
1400 Ocean Drive.

Here is a hotel built in 1941, by one of the leading Art Deco architects of the day, and it is nothing, really, like anything else on the street. It is, more than anything, "colonial" in style. This may make sense for a building called the "Betsy Ross" (who, you may recall, is credited with designing the first "stars 'n' stripes" American flag), but has almost nothing to do with South Beach, Miami Beach or Florida, all of which were under more Spanish than American influence during the American Revolutionary period. If you're a purist about your architecture, the Betsy Ross may just seem not to "belong." But if you're beginning to understand the premeditated postcard nature of South Beach, you'll understand that the Betsy Ross is the perfect counterweight to any chance that Ocean Drive will forget its made-up nature as an "Avenue of Dreams," from any era you may want to visit.

Chapter Seven
Collins Avenue
Reaching for the Sky

While Ocean Drive is justly famous for its sheer number of small Art Deco structures, many classic buildings of the era were built on the next thoroughfare to the west, Collins Avenue. In most ways, Collins Avenue is the best known street in Miami Beach, since it runs continuously (unlike Ocean Drive) the entire south-to-north length of the island. And because it is so close to the Atlantic Ocean, actually the closest street to the beach for most of the city's length, it was a natural locale for the early twentieth century growth that led to the Art Deco explosion in South Beach.

It is a very short walk from your starting point at Tenth Street and Ocean Drive over to the corner of Tenth and Collins, where you'll be rewarded for your effort by the sight of the Essex House Hotel at 1001 Collins. The Essex House sports one of the most graceful rounded corner entrances in South Beach, as well as portholes, over-window eyebrows, and a whimsical spire that characterizes so much of Art Deco South Beach style. Because it is on an open corner lot, there is an opportunity to view all these details at the same time in a way that is not usually available along Ocean Drive.

Essex House Hotel, Henry Hohauser, 1938, 1001 Collins Avenue.

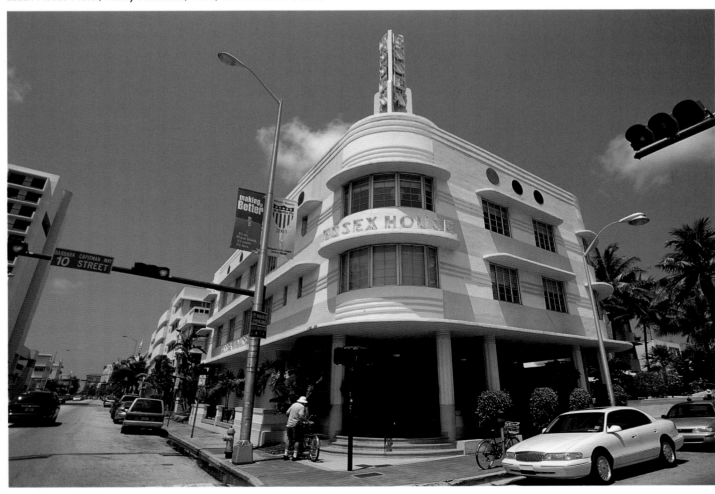

In the 1100 block of Collins stands a grouping of hotels, including the Tudor (at 1111), the Palmer House (1119), and the Kent (1131), which create a little forest of nautical Art Deco that is a feast for the eyes and the spirit. All of this seems to lead naturally to the Marlin Hotel, at 1200 Collins (see photo on page 9), a streamline beauty that was lovingly restored during the Miami Beach renaissance of the 1990s. This streamline theme is continued in the Webster, a 1936 hotel at 1220 Collins.

On your way, don't miss the chance to stop in or visit the Collins-facing terrace of Jerry's Deli (see photo on page 34) at 1450 Collins. This building was originally built in 1939 as a cafeteria, but has since witnessed a parade of clubs and restaurants, culminating in the fine renovation achieved by its current occupant. Don't forget that Jerry's is open 24/7; so you can take this Collins Avenue tour at any time of the day or night.

Kent Hotel, L. Murray Dixon, 1939, 1131 Collins Avenue.

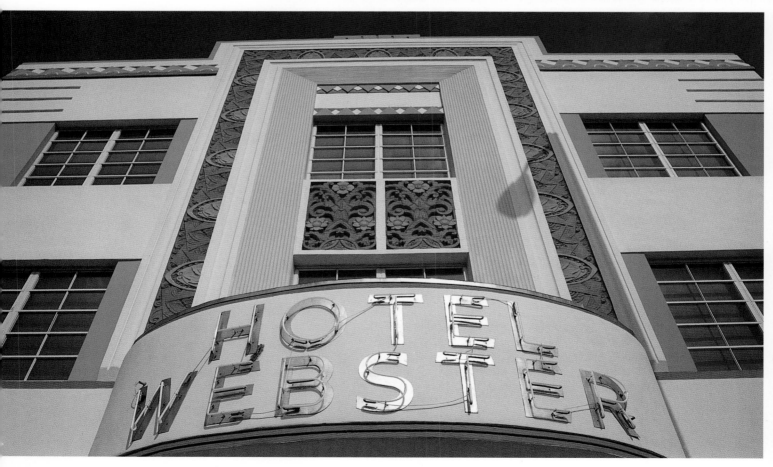

Hotel Webster, Henry Hohauser, 1936, 1220 Collins Avenue

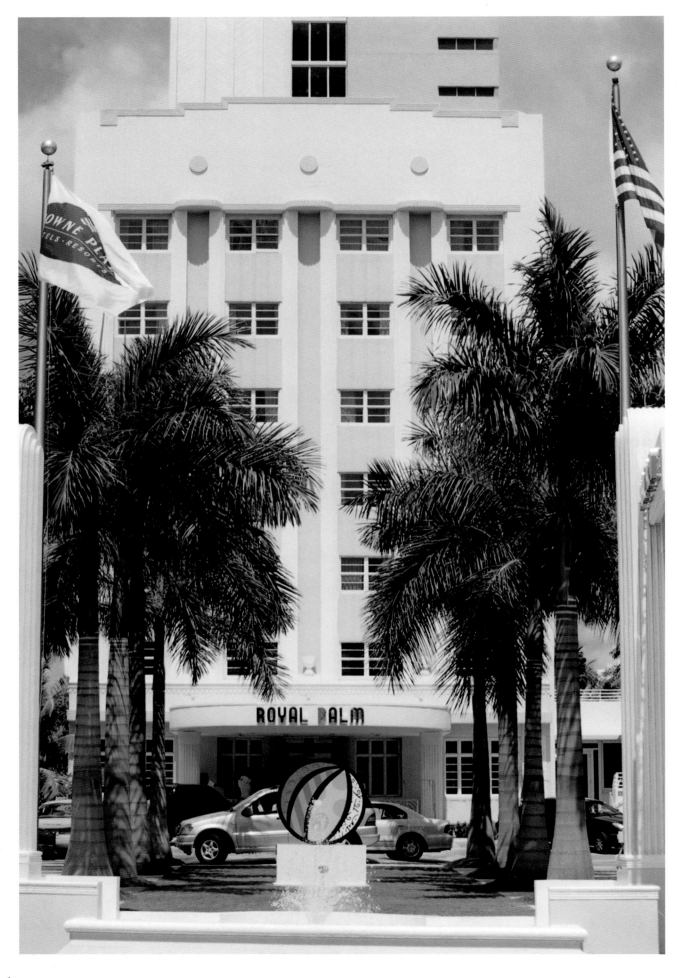

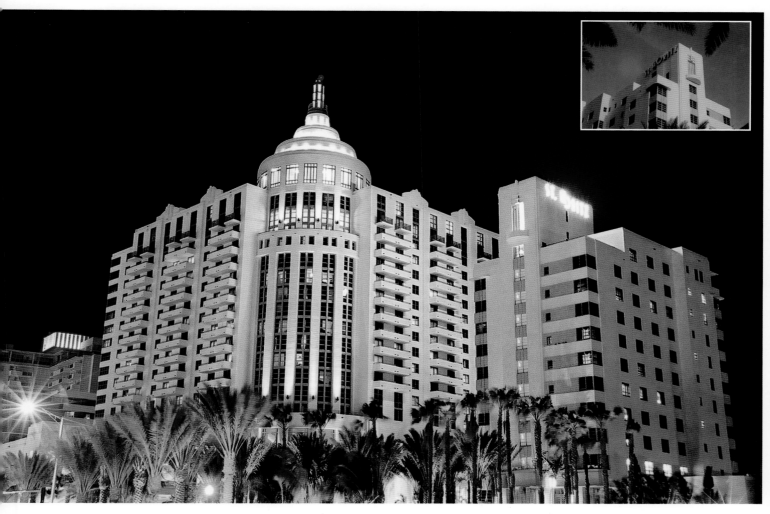

The Loews Hotel incorporated The St. Moritz within its property and restored it to its original beauty (conceived by Roy France in 1939). The Loews, located at 1601 Collins Avenue, is a glamorous complex that prides itself on being the most inviting convention hotel in Miami Beach.

Continuing your northerly route along Collins will take you through some of the most interesting real estate in South Beach, an area where the three-story style of Ocean Drive and lower Collins begins to yield to more and more soaring structures. Among these are the meticulously replicated Royal Palm Hotel in the 1500 block of Collins, the recently built but distinguished Loews South Beach (which incorporates the original structure of the 1939 St. Moritz Hotel at 1565 Collins), and a newly "hot" area called by some residents the "Upper East Side."

◄
The Royal Palm Hotel, originally built in 1939 by Donald Smith, has recently been reconstructed and glamorized in elegant fashion.

The signature stretch of buildings in this newly hip Upper East Side neighborhood lies along the stretch from Lincoln Road on up to 19th and Collins. At the eastern end of Lincoln Road itself, the new Ritz-Carlton Hotel has preserved and incorporated elements of the DiLido Hotel structure which once stood in this space. Walking north, you'll see signs of the late 1930s/1940s' yearning for height. The results, which include the then-towering structures of the National, built in 1940, and Delano (1947) Hotels in the 1600 block, have now become synonymous with the height of South Beach style (with room prices to match). One of the Delano's special features, aside from its reputation as one of the coolest places around, is that it is another good example of the use of multiple corners by architects working in the pre-air conditioned Art Deco years. The effectiveness of the Art Deco renaissance during the 1980s and 1990s is exemplified beautifully by the transformation of this block of buildings from a neglected backwater to a newly vibrant (and very "in") hotel row.

The Ritz-Carlton South Beach, located at 1 Lincoln Road, has recently opened its doors to well-heeled tourists and business men and women who seek a new hotel with old world charm and grace.

The National Hotel, another Roy France creation, built in 1940, has reestablished itself as one of the finest South Beach Hotels. It underwent a major restoration that Art Deco preservationists have applauded. The interior takes you back to the grandness of the Art Deco era.

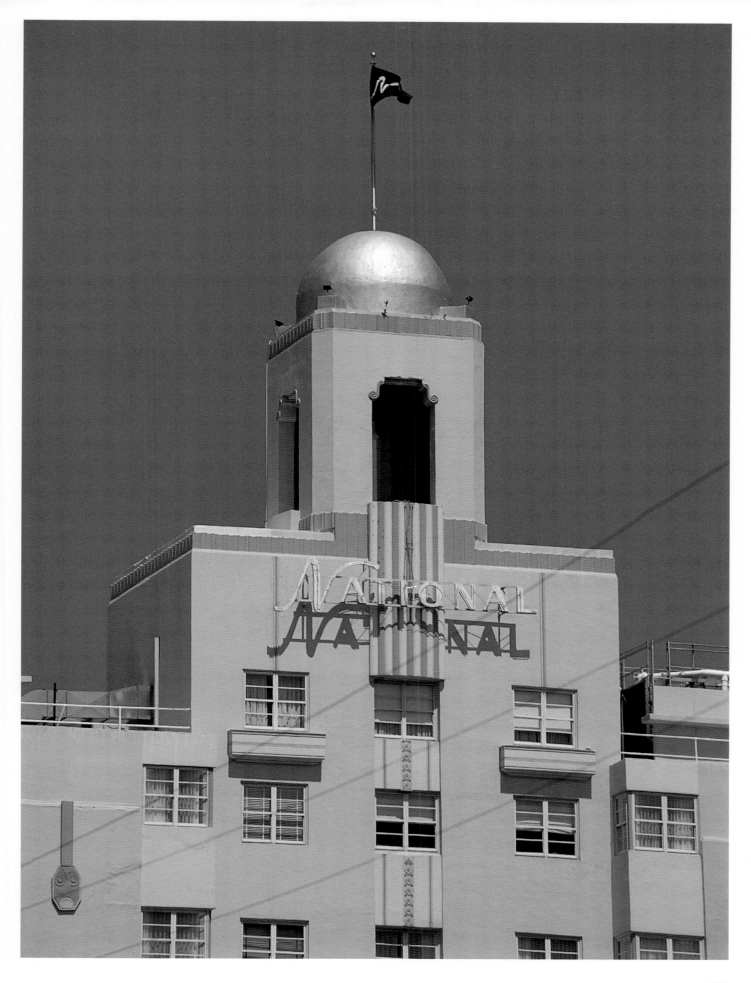

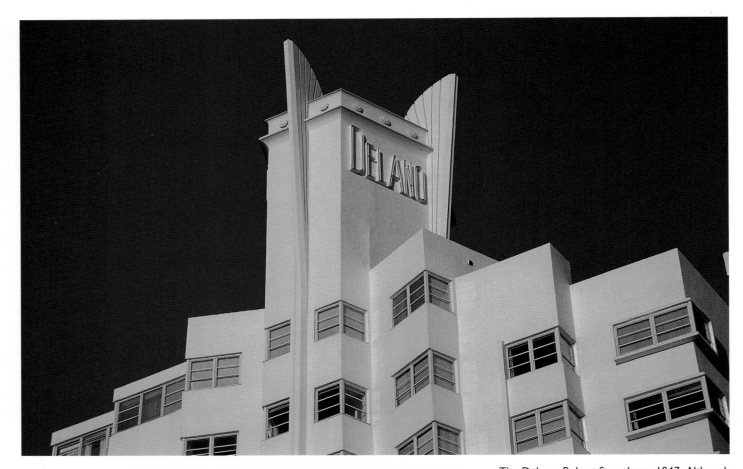

The Delano, Robert Swartburg, 1947. Although the exterior is as it was in Miami Beach's heyday (with the addition of a lot of white curtains) the interior was gutted and re-created by Philippe Starck and makes a statement that can only be understood by going inside.

The Delano, against a nighttime sky, magnifies all its whiteness and sets the stage for the glamorous entertaining that you'll experience upon stepping within. No wonder Goldfinger was filmed at this site.

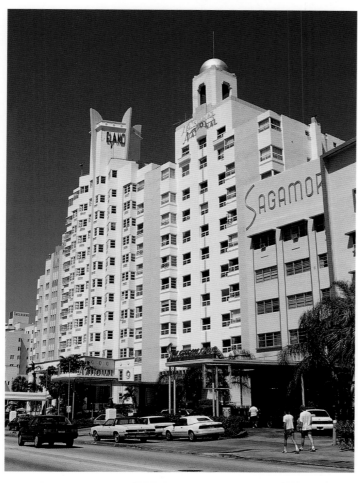

Upon a close look you can see the deterioration that occurred prior to these hotel restorations. Is that the "elano" Hotel? Renovated by Peter Gumble in the mid-'90s.

What a difference a decade makes.

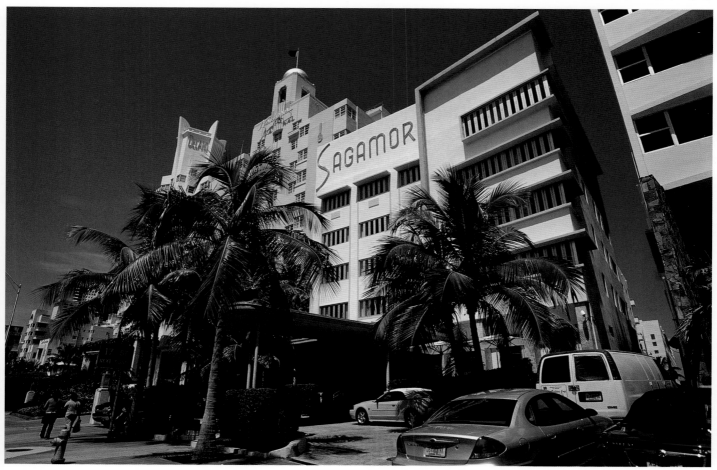

Of special note in the 1700 block are the following: the Ritz Plaza with its rooftop tower, built in 1940 at 1701 Collins; the cute, low-lying Surfcomber (1948) at 1717 Collins; the Marseilles (1948) at 1741 Collins with its "Chinese-Deco" iron grilles surrounding the hotel's main sign and its multi-cornered design; and the Raleigh (1940), famous for its gorgeous swimming pool area but also for its gracefully curved corner at 18th Street. On the other side of 18th Street along the Ocean sits the Shelborne, built in 1954 and noteworthy for its graceful, whimsical Art Deco signage.

Beyond the 1800 block, the parade of newly hip hotels continues with the Shore Club at 1901 Collins.

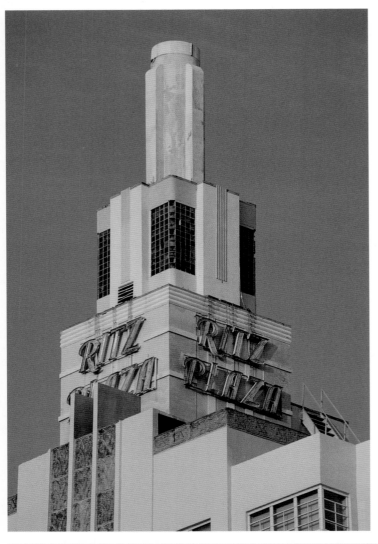

Ritz Plaza, L. Murray Dixon, 1940,
1701 Collins Avenue.

The Collins Avenue hotels pay attention to one another when selecting their shades of color. They often form a rainbow of hues that make you look again and again.

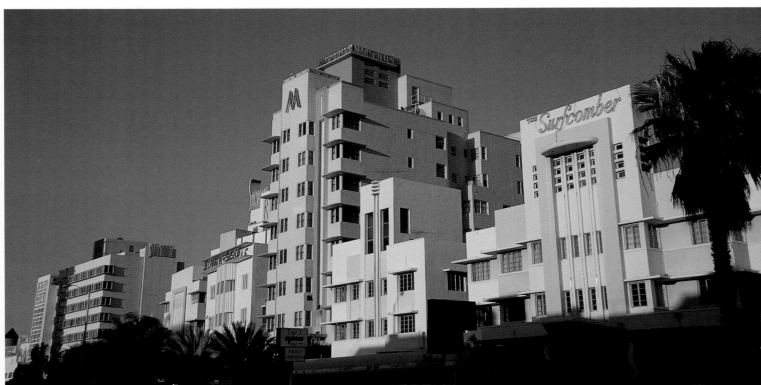

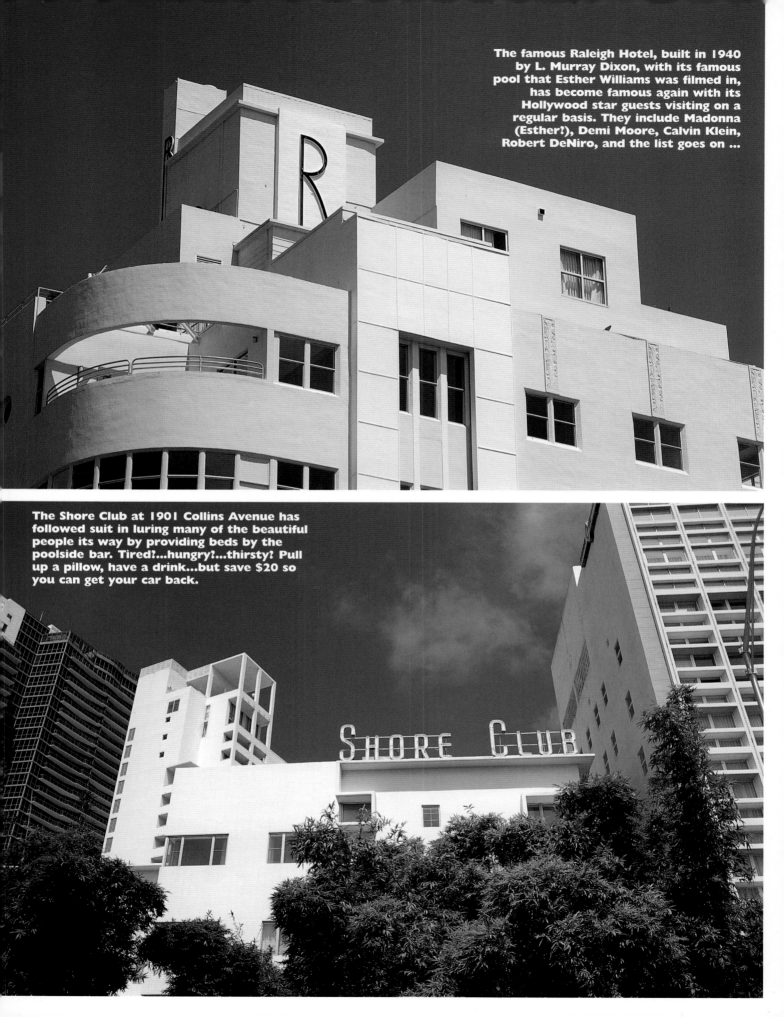

The famous Raleigh Hotel, built in 1940 by L. Murray Dixon, with its famous pool that Esther Williams was filmed in, has become famous again with its Hollywood star guests visiting on a regular basis. They include Madonna (Esther?), Demi Moore, Calvin Klein, Robert DeNiro, and the list goes on ...

The Shore Club at 1901 Collins Avenue has followed suit in luring many of the beautiful people its way by providing beds by the poolside bar. Tired?...hungry?...thirsty? Pull up a pillow, have a drink...but save $20 so you can get your car back.

Collins Avenue is so rich in interesting sights that you can actually follow the whimsical architecture completely out of the bounds of South Beach, all the way to the Seville Beach Hotel, at 2901 Collins; the Versailles at 34th and Collins; and even as far as the world famous Fontainebleau and Eden Roc Hotels, all the way up at 44th and 45th Street.

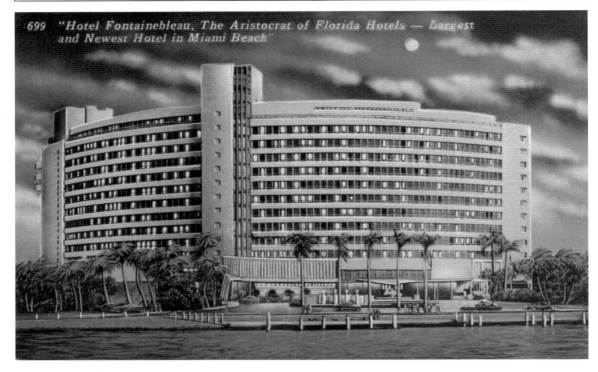

699 "Hotel Fontainebleau, The Aristocrat of Florida Hotels — Largest and Newest Hotel in Miami Beach"

The Fontainebleau Hotel at 44th and Collins, where everyone flocked during the fifties (if they could afford it). Designed by Morris Lapidus in 1954, this hotel was supreme. It continues to be quite luxurious and is worth a visit. Postcard, Tichnor Bros., Inc.

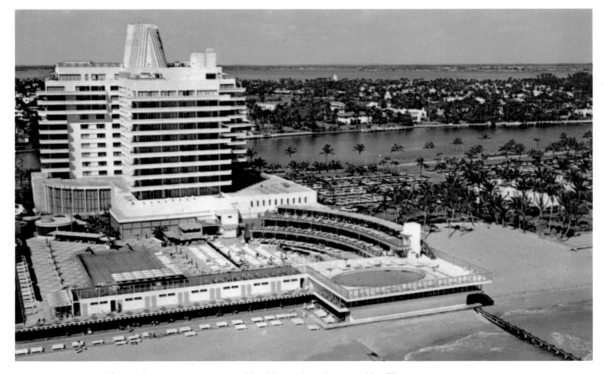

The Eden Roc at 45th and Collins, also conceived by Morris Lapidus, was like The Fontainebleau's sister. If the Fontainebleau had no rooms left, you went to the Eden Roc and vice-versa. The lobby is missing only Loretta Young. Postcard, Curtechcolor.

The sights are almost as rewarding if you take the route south from Tenth Street, starting at 1000 Collins with what was once known as the Fairmont Hotel. It has now changed its name to the "Fairwind" for legal reasons. The Fairmont/Fairwind boasts, among other things, one of the most generous side gardens in South Beach. While you're in this area, by the way, take a moment to appreciate the somewhat strange but always interesting Coral House at 900 Collins. It is about the only free-standing house left in this part of South Beach and has been used for office or retail purposes for quite some time. At 901 Collins stands the Sherbrooke Hotel, built in 1947 and featuring a host of details and design themes from the nautical Art Deco school. And don't

miss the Franklin and Whitelaw Hotels in the 800 block of Collins. These are both genuine Art Deco creations from the 1930s. You'll find streamline themes at the Whitelaw, a 1936 hotel at 808 Collins. At the corner of Eighth Street and Collins stands the Tiffany Hotel, except that you're only allowed to call it the "Tiffany" while in South Beach. Due to a legal challenge involving New York's famous Tiffany jewelry emporium, the hotel once known as the Tiffany is now referred to simply as "THE Hotel" in all literature and references that go beyond the narrow confines of the Art Deco District. Whatever you want to call it, it is a beautiful collection of tropical Art Deco details such as a narrow roof-spire and porthole shapes.

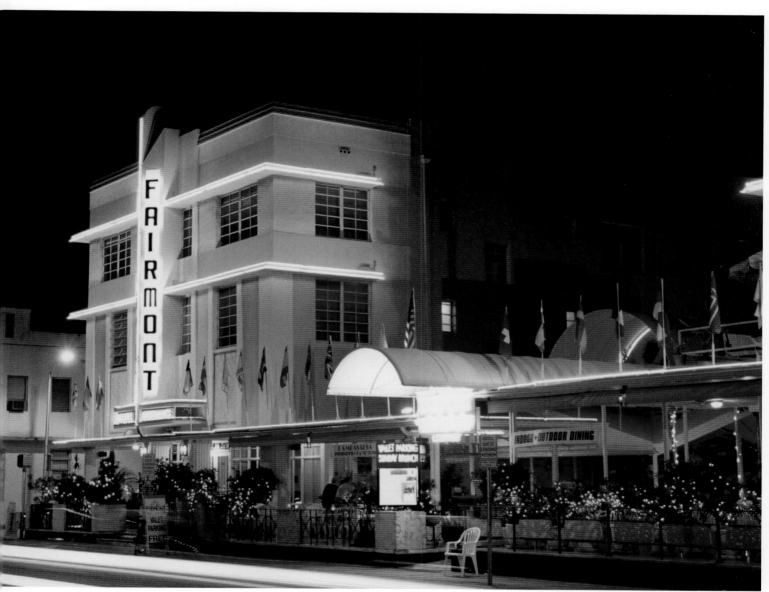

The Fairwind Hotel, formerly named the Fairmont, at 1000 Collins Avenue, was built in 1936 by L. Murray Dixon.

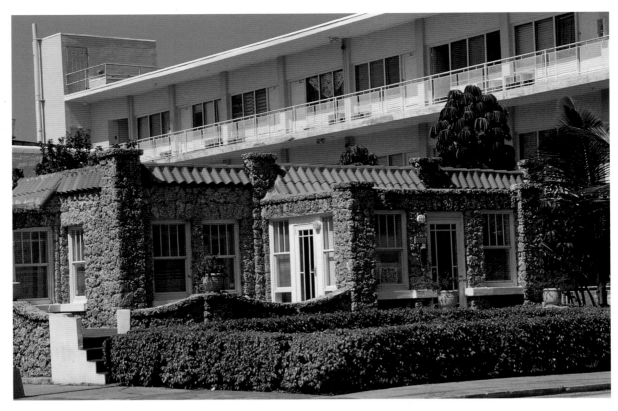

The Coral Rock House at 900 Collins Avenue. At this writing it is facing the threat of demolition. Here's hoping it's still here when you are.

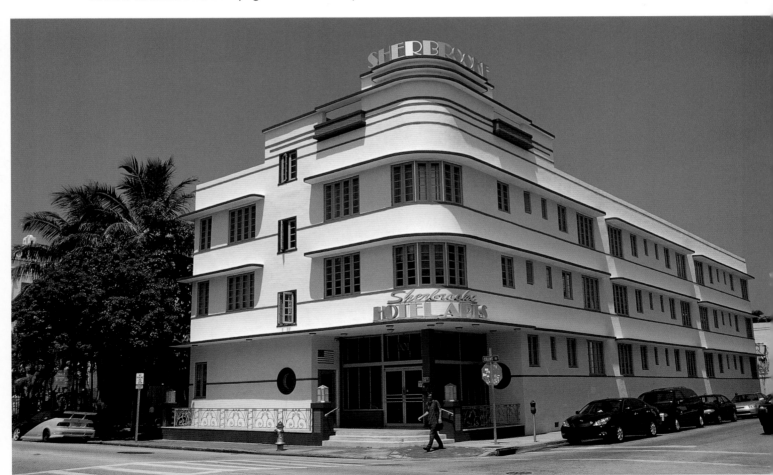

Sherbrooke Hotel, Gibbs and MacKay, 1947, 901 Collins Avenue. This hotel is a perfect example of nautical Art Deco architecture. Climb on board and stay awhile.

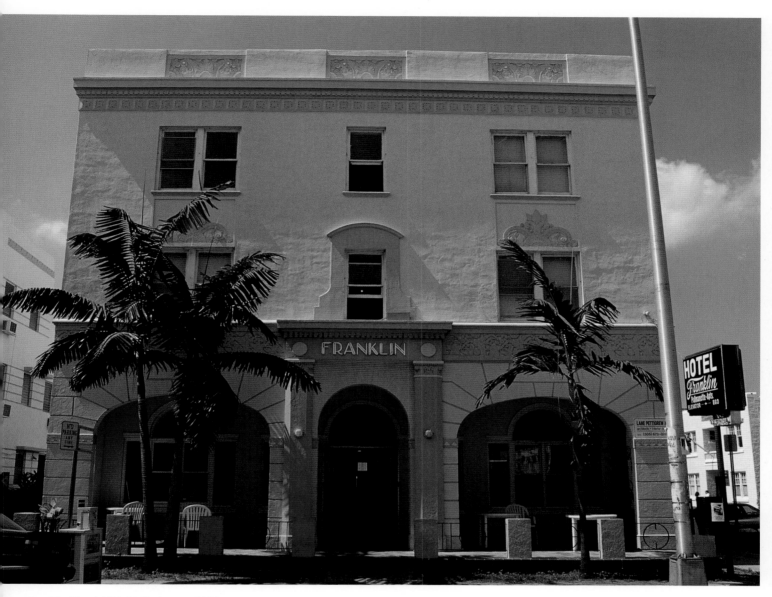

Franklin Hotel, V.H. Nellenbogen, 1934.

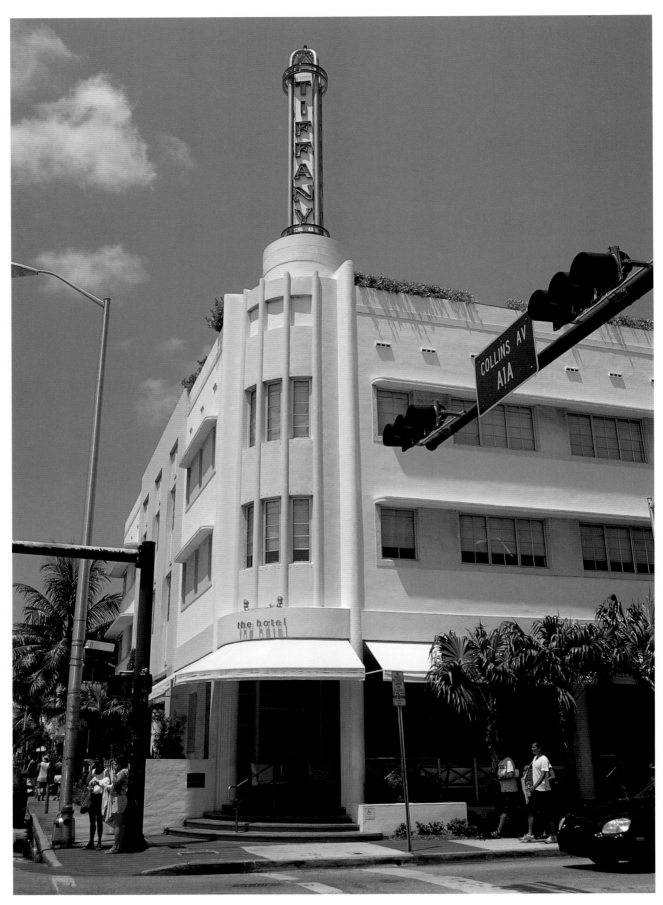

The Hotel, formerly The Tiffany, will always bear the Tiffany sign, thanks to preservationists. Built in 1939 by L. Murray Dixon. Step inside…It's a winner!

The original "TIFFANY" neon sign has been allowed to stay, thank goodness (and thanks to our preservationists).

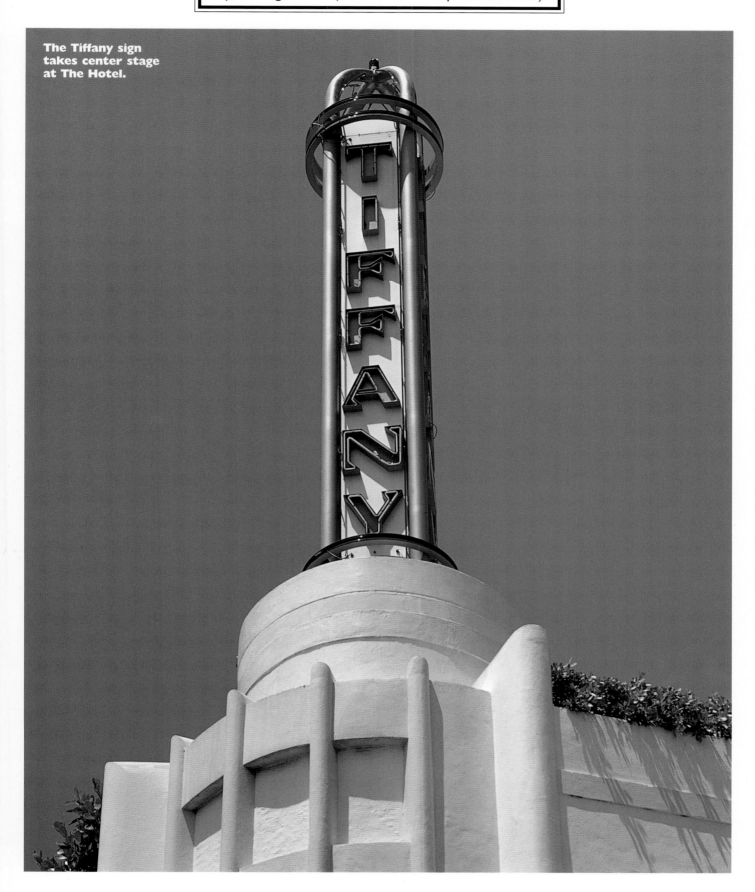

The Tiffany sign takes center stage at The Hotel.

Chapter Eight
South of Fifth

During the "bad old days" before the South Beach renaissance that began in the late 1980s, the area below Fifth Street, sometimes called "south of Fifth" or "SoFi," was about as much of a no-go zone as existed here. But my, how things have changed! It would be fair to say, in fact, that many of the most desirable new spots in town are now appearing in this area.

Let's start with the oldest of old standbys – Joe's Stone Crab Restaurant, an institution in South Beach from well before even the Deco period. In fact, Joe's traces its history all the way back to 1913, when a man named Joe Weiss opened a lunch counter of sorts at the southern end of Miami Beach. Today, the restaurant stands near the same spot, at the southern tip of Washington Avenue, and is literally world famous for its local seafood specialty, the stone crab. Unfortunately, it has also become famous for its gargantuan waiting times and its equally gargantuan prices. But if you're in the mood (and have the cash) to treat yourself to a historic-type experience, plan on using up a chunk of your day waiting for a table at Joe's.

It wasn't so long ago that locals would have told you that the ONLY reason for venturing south of Fifth would be to eat at Joe's. But, as I said, things have changed. You can start at your Tenth Street and Ocean Drive "home base" and simply walk south – toward the direction in which the street numbers descend. Within a few blocks, you'll see that the characteristically dense hustle and bustle of the Ocean Drive "wedding cake building" area has given way to a slightly more laid-back atmosphere. You've arrived at the area of Fifth Street.

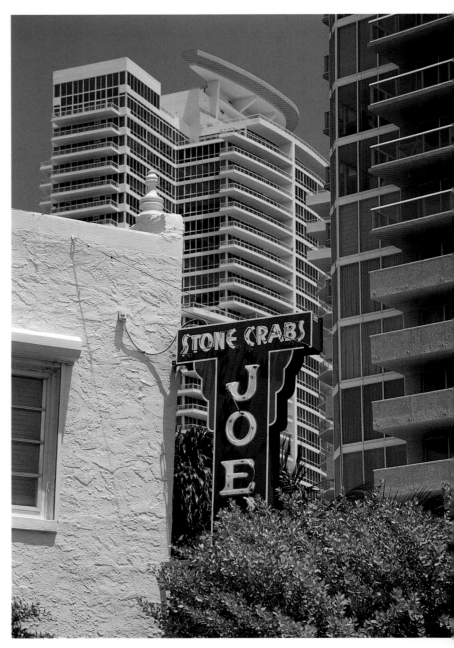

Sign of Joe's Stone Crabs amidst the towering new construction of South Point.

Portofino Tower, South Point.

You can take one look at the new skyline in this area and see that there has been an incredible boom in the building of new, very interestingly-shaped high-rise condominiums. Many of these are on the western side of the island where it meets the MacArthur causeway toward downtown Miami. A lot of people in town don't necessarily like these condos, and one of the most consistent lightning rods has been the Portofino Tower Building, a massive skyscraper condo that you can't miss as you look toward the southern tip of Miami Beach below Fifth Street. Nobody's quite certain what "style" the Portofino is supposed to be. It looks to me like a mixture of Deco, Mediterranean, and Fantasyland. But what I think ultimately makes it acceptable in Miami Beach is that it has whimsy to it, the quality of not taking itself too seriously (at least I HOPE the building's designers didn't think they were being fully serious). This same sense of playfulness is evident in the detailing at 248 Washington Ave., which includes a sort of Deco turret with fish swimming around it, as in a whirlpool (or, perhaps, in a bad dream after an overindulgent South Beach evening).

Whimsy is an element of even not-so-old construction on South Beach.

The Continuum Condominium, South Point.

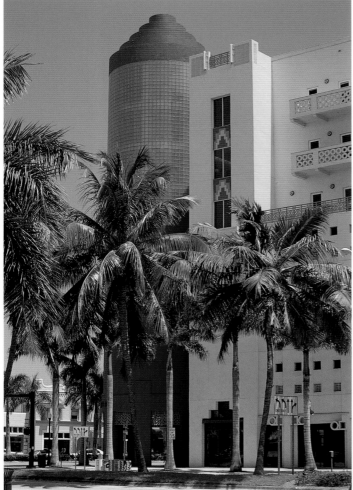

The Thomas Kramer Building that houses China Grill, corner of 5th and Washington Avenue.

In any event, on the west side of the island, just below Fifth, there has been an explosion of high-quality building, much of it going by confusingly similar names (many "Muranos" and, now, several kinds of "Portofinos"). So, if you're heading south of Fifth to meet a friend down there, make certain that you get the exact name of the building where you're meeting. One of the characteristic "Miami Beach" touches in this cluster of buildings is that they seem to have been designed with "hats" of one kind or another protruding from their roof-decks. Perhaps this is a return to the sensible idea that, during much of the year in South Beach, shade from the sun can be a very good thing. This same "hat"-type element is also in evidence at the beautiful new Continuum Condominium at the east end of the Island's tip.

At the corner of Fifth Street and Washington, you won't be disappointed if you take a stroll through this area at night just to check out the ever-changing colored lights in the turret of the building that stands there. It houses, among other things, The China Grill, a somewhat "been-there" place that is fun if you don't mind spending a little cash, but is also controversial – just like the building it's in. Some of Miami Beach's most important architectural authorities HATE this building. Whatever your opinion is, you'll have to concede that it's at least, uh…interesting. Across the street from this building is a strip of restaurants – some long-lived like "Tuscan Steak" and some more come-and-go – that have traditionally been of high quality and lower price than comparable surroundings just a block or two away on Ocean Drive.

Check out the recently constructed South Beach Marriott at 161 Ocean, and you'll see an example of how an older architectural element has been incorporated into the new hotel.

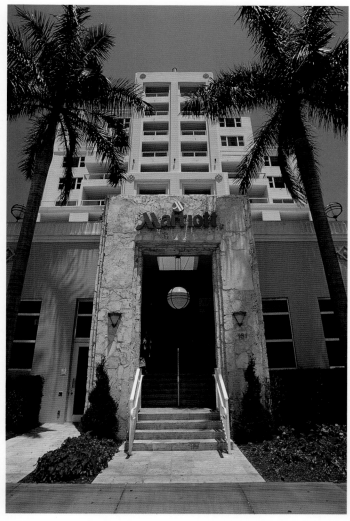

The Miami Beach Marriott at South Beach, 161 Ocean Drive, has both the look and the feel of South Beach style inside and out.

Along with the south-of-Fifth building boom has come a boom in the emergence of new stylish clubs, restaurants, and hotels. On the Ocean side of the southern tip of the island stands a series of clubs founded by people who also operate clubs in St. Tropez, along the French Riviera. For many international travelers, the mere words "St. Tropez" suggest a level of sophisticated playground that is unmatched, and the clubs along this stretch of Ocean Drive below First Street will not disappoint that expectation. Perhaps the most famous is Nikki Beach Club. Here, you can while away an afternoon or an evening being sort of halfway between a day at the beach and a night at a disco, with a beautiful bar to match the beautiful people who tend to hang out at Nikki's.

By the way, if you're into "the club scene" in Miami Beach, or would like to be, it will be a good idea to ask around at restaurants and bars about which night of the week "belongs" to which club, and for which kind of clientele. There are clubs here that have claimed one or another night as their "own," and several of the clubs (an ever-changing list of names which tend to open, close, and re-open at the same addresses) will have one night for gay patrons and another for straight. Another thing that you should do if you're interested in the club scene is to adjust your sleeping patterns so that you can fit in with the typical clubbing hours, which tend to run between midnight and 6 or 7 AM. There is an entire culture in Miami Beach devoted to the "power nap," which typically is a two-three hour slumber best had from 7 to 10 PM, just before getting ready for your appearance at the club of your choice.

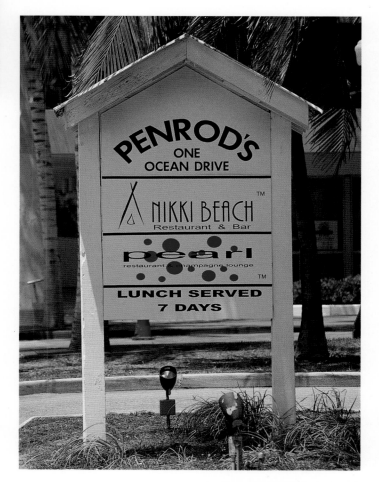

The sign of the Penrod complex, offering good food and good fun, day and night.

Just up and across the street from Nikki Beach, at 112 Ocean, is the venerable Brown's Hotel, said by many to be the oldest existing building in Miami Beach. The Century Hotel stands in the same block, at 140 Ocean. One of the nicest architectural statements in this area is the synagogue building that now houses the Jewish Museum, at Third Street and Washington. There are certainly others, including a collection of small hotels that have renovated their surroundings and sort of look the way the area did north of Fifth about twenty years ago. Real estate investment anyone?

And there are other clubs south of Fifth aside from Nikki Beach. One of the most stylish is located at Second Street and Collins Avenue. At this writing, it goes under a variety of names, depending on which room you think you'll want to hang out at, but it can be accessed by calling it either "Club Privé" or "Opium." What is especially cool about this club is that most of the space it occupies is open to the sky. While this may be a problem for the neighbors, some of whom might actually want to sleep between the hours of midnight and 7 AM, it is no problem at all, and a special kind of atmosphere, if you're among the crowd INSIDE of the club.

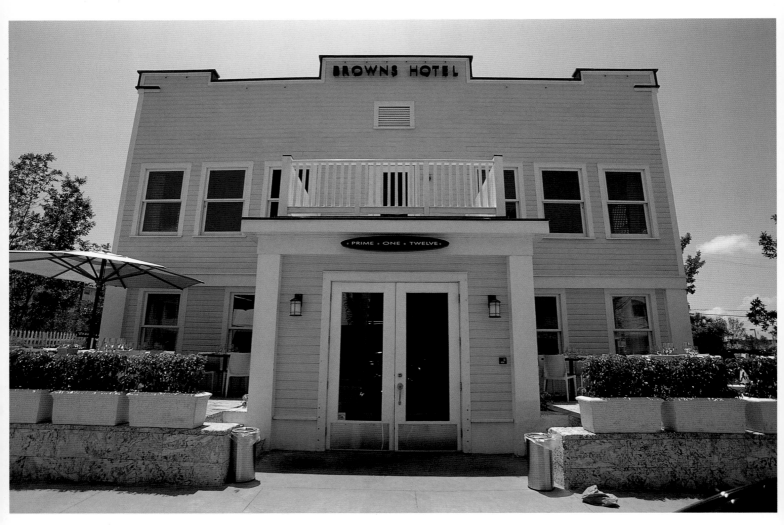

Brown's Hotel, 112 Ocean Drive, houses the currently famous Prime 112 Restaurant (steak anyone?). Built in 1915 and renovated in 2001 by Allan Shulman.

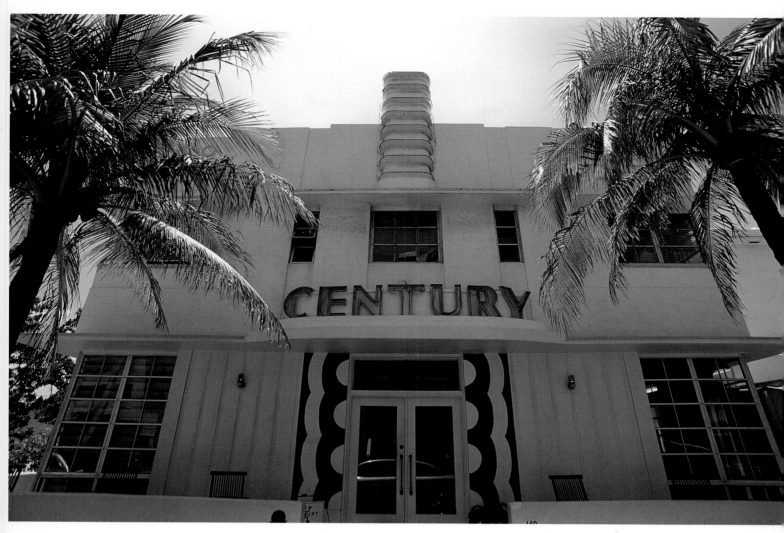

Century Hotel, another nautical Art Deco treasure, 140 Ocean Drive, wearing its new blue and white motif. Built in 1939 by Henry Hohauser.

Across the street from Opium is a funky kind of eatery called "Big Pink," which serves a variety of fare and is a great place to see and be seen. Also along the most southerly block or two of the island are a variety of other good restaurants, including Nemo, at Collins and First Street. And, on Fifth Street itself, you might want to stop in for dinner and Island music at Tap-Tap, an authentic Haitian restaurant and club at Fifth and Jefferson.

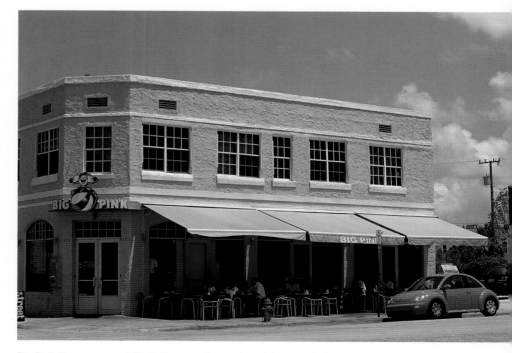

Big Pink Restaurant at 161 Collins...and one of its delivery vehicles, a pink VW Bug.

Two Paths Less Taken

North along Lummus Park
and the Lifeguard Station Tour

From your starting point at 10th Street and Ocean Drive, you can take two little-noticed tours that I highly recommend. The shorter of these is just a five block walk north or south along the green space called "Lummus Park" that runs along the beach virtually the entire ten blocks between 5th and 15th Streets. The especially neat thing about walking through the winding path in this little park is that you get a unique and generally under-appreciated view of the famous Art Deco hotels along the west side of Ocean Drive. Most

people will tend to stroll along that west side of the street, near all the activity of the hotels and cabarets that line this famous thoroughfare. A somewhat smaller, but still sizable, number of revelers tend to walk along the east side of the street, across the street from the hotel buildings. But if you're REALLY in the know (and, now that you're reading this book, you are), you should also travel a path less taken, the path through Lummus Park.

The Lummus Park sign, welcoming you to the stretch of greenery between the sidewalk and the sand.

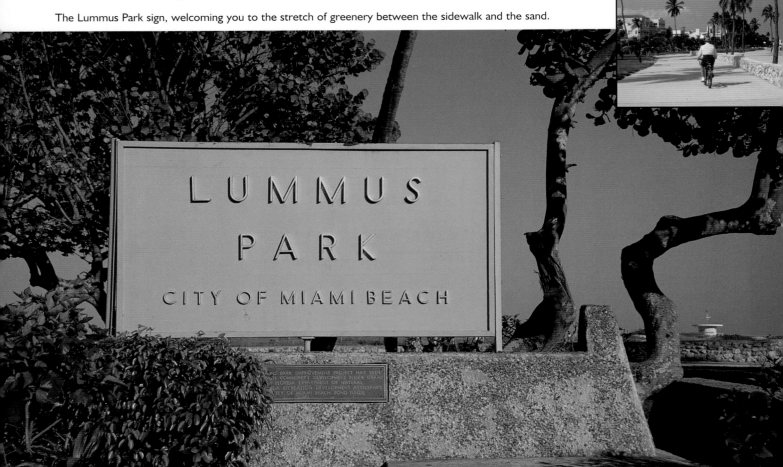

From this path, you get a different and more panoramic perspective on these special buildings that have become the signature of South Beach Art Deco architecture. In the morning the sun will be rising over the blue Atlantic and illuminating the facades of these buildings so that you can see every detail of the whimsical touches unique to this architectural tradition.

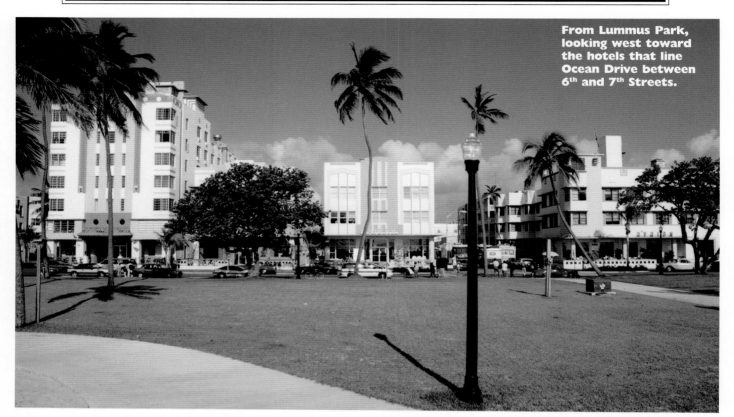

From Lummus Park, looking west toward the hotels that line Ocean Drive between 6th and 7th Streets.

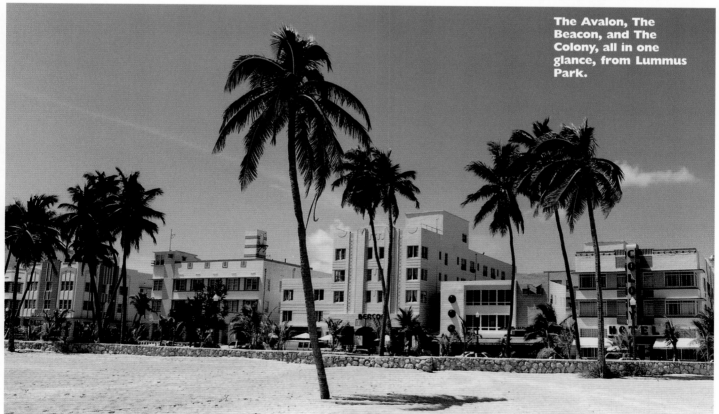

The Avalon, The Beacon, and The Colony, all in one glance, from Lummus Park.

In the early evening, the neon lights and signs come to life, and there is no better way to see the panorama of these lights than from your Lummus Park location. These hotel facades are a special treat whether they are illuminated either by sunlight or by neon. If you want to take the quick course in what makes Ocean Drive such a special place architecturally, the Lummus Park tour is a good way to go.

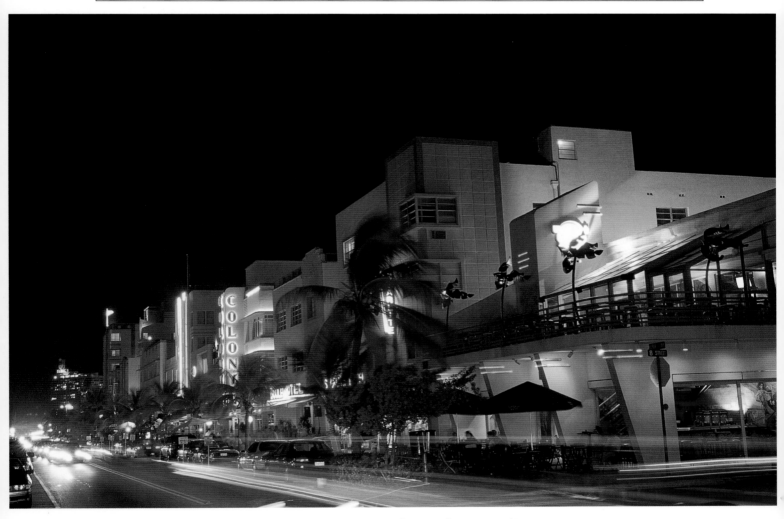

From Lummus Park, you can see the neon and the nighttime scene, a perfect spot for picture-taking.

Our second path-less-taken will introduce you to one of South Beach's little secrets. You start this tour by going east from 10ᵗʰ and Ocean. "East?" you might ask. Yes, east…even though the only thing east of Ocean is the beach itself and the beautiful rolling Atlantic behind. Here's the secret part. There actually is one category of nautical architecture that sits in that lovely space, and that is…(drumroll)…the lifeguard stand.

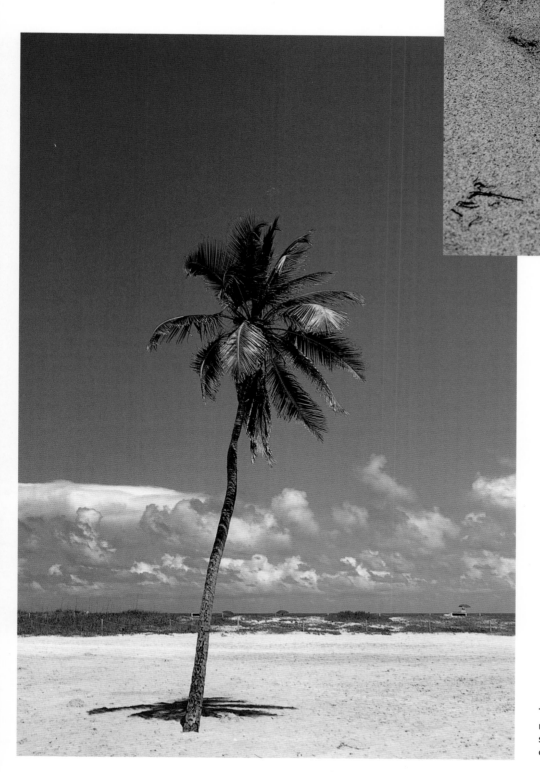

Enjoy the sand between your toes while you come upon the colorful lifeguard stations; and don't forget to reapply your suntan lotion.

The swaying palms and ocean breeze may distract you from the sun's rays, so don't forget to wear a hat and lots of sun protection (2ⁿᵈ Warning).

But, this being South Beach, the lifeguard stands aren't anything like just plain old lifeguard stands. Instead, they're a variety of kitschy, colorful shapes and colors lining the beach all the way up to 40th Street and beyond. You can stroll along the Beach, with the Atlantic in your ears, the sun warming you all over, and literally break out in smiles and laughter at the sheer "adorableness" of these lifeguard stands. No two are exactly alike, and they each evoke a sort of "Art Deco Echo" of the buildings facing the beach. There are some that look like 1950s furniture; others look like a little ice cream sundae with stairs leading to the goodies on top; still others look like a Caribbean thatch-roof hut in wild and crazy colors.

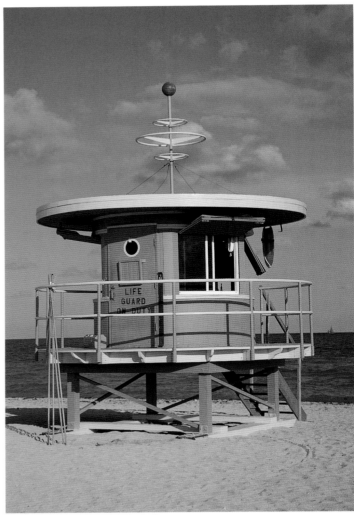

Kenny Scharf's magical lifeguard stand has been used in many promotional ads for South Beach and beyond.

and another...

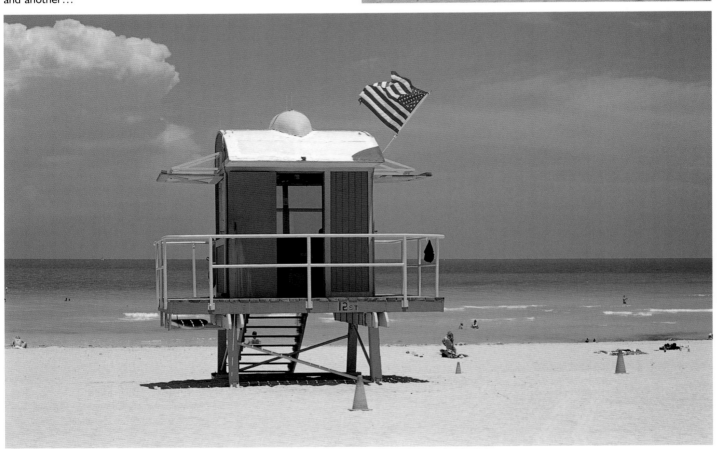

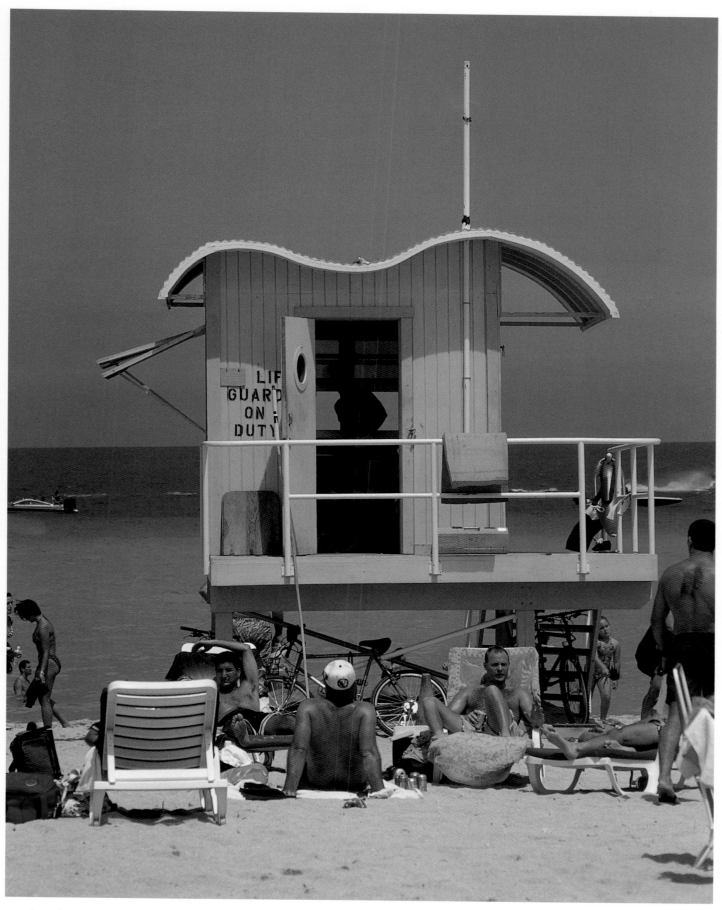

...and another...

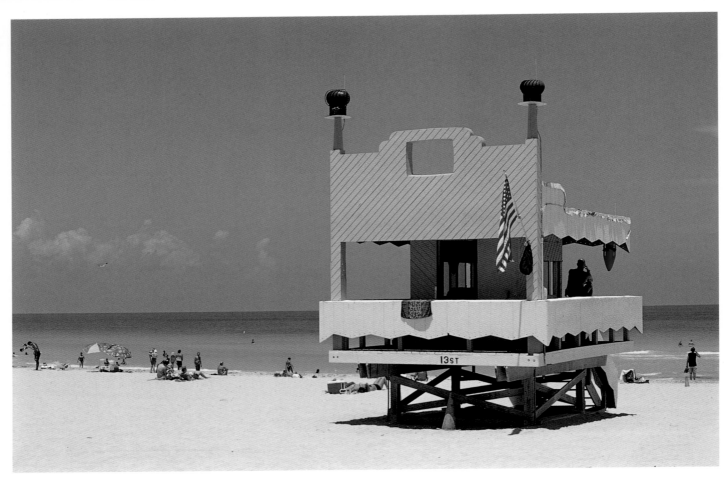

...and another...

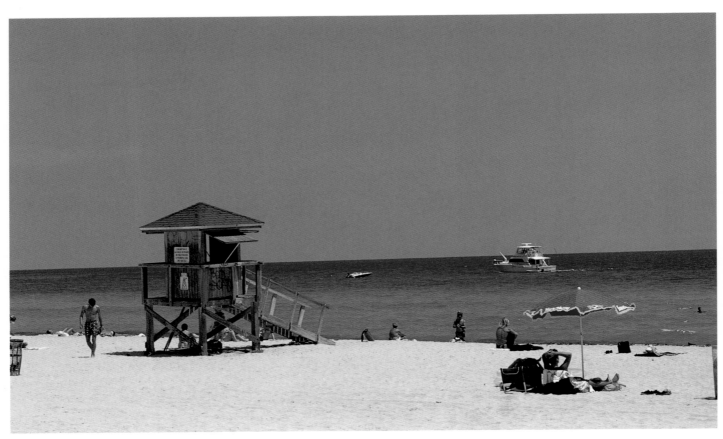

...and another...

...and another...

…and another…

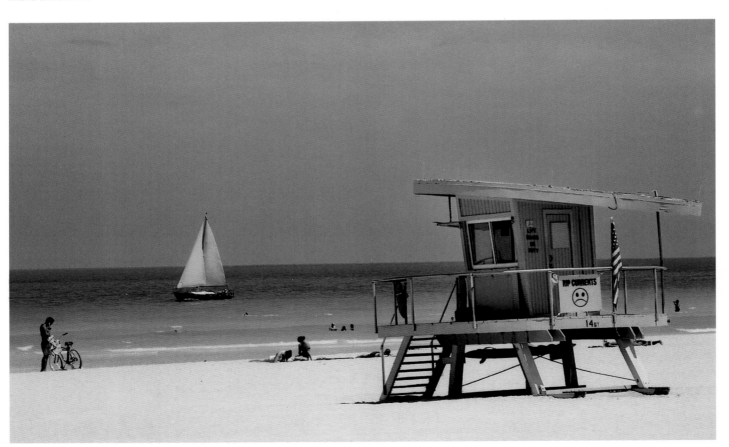

…etc.

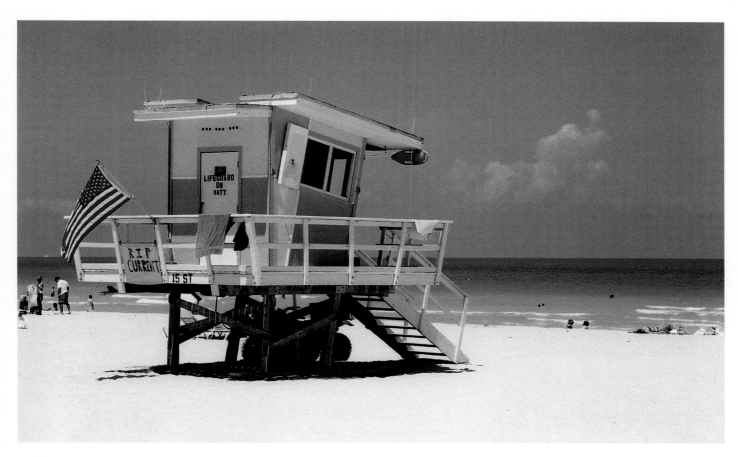

...etc.

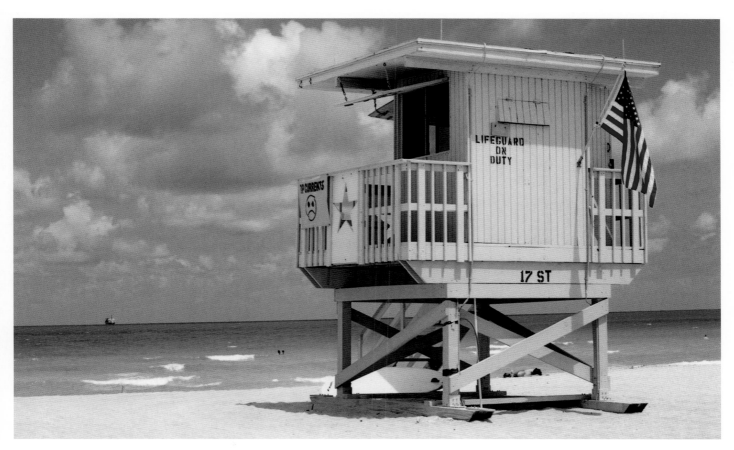

...etc.

All in all, they're quite a collection of little architectural art objects, a real treat for those who know where to look for them. For those of you who like to jog or just walk along the beach, this is a tour that you can take with bare feet…so make your footprints in the sand or at the Ocean's edge. And if or when you get to 21st St., you can change your perspective by taking the beachside boardwalk which extends all the way to 46th St. Please remember your suntan lotion (SPF 15 or higher, or you'll be uncomfortable for the rest of your stay!).

take a rest…you can discover the others tomorrow.

Chapter Ten
Lunch (Brunch?)

One of the nicest things about your Miami Beach walking tour is that, within five blocks from your starting point at 10th St. and Ocean Drive there are oodles (that means "a lot") of places and ways to stop and have a casual or elegant lunch. And, because of the "odd" hours that the all-night Miami Beach nightlife creates, you can find something really interesting for "lunch" no matter whether the middle of your day is noon (like normal people in the real world) or 6 PM. Even better, you can have an exciting lunch for as little as $7/person and as much as $40, or even more. Let's start on the high end. Some of the hotel cafés along the west side of Ocean Drive not only serve hot food but also tend to serve it to a "hot" clientele. While the food-style and restaurant mix here ebbs and flows with the years (partly because these places must do very well financially to pay the high Ocean Drive rents), there has been a general tendency toward Northern Italian (Tuscany and north) cuisine — including eateries housed in some of the finest restored examples of tropical Art Deco architecture to be found anywhere.

Caffé Milano, at 850 Ocean Drive, has been around for years, offering its patrons a feeling of the Italian Riviera or the beachside resort town of Riccione on the east coast of Italy. At Caffé Milano, the sky and the mood are (or, at least, seem to be) always crystal clear. You'll pay more for your lunch than you're used to, but you'll also get some payback that you just can't get anywhere else – an atmosphere of unrushed Italian service (and, for the most part, with a real Italian as your waiter or waitress), a clientele that is dressed in everything from Gianni Versace (who used to live near here, but more about that elsewhere in this book) to almost nothing at all. Try the soups on the rare chilly day, or any of the wholesome and delicious Northern Italian salad-type luncheon specialties on most any day.

In the same price class (and I do mean "class") as Caffé Milano is the restaurant at The Tides Hotel (1225 Ocean). Less pricey and extremely popular with both residents and tourists are two other Ocean Drive cafes: The Front Porch Café (between 14th and 15th St.) and The News Café (on the corner of 8th and Ocean).

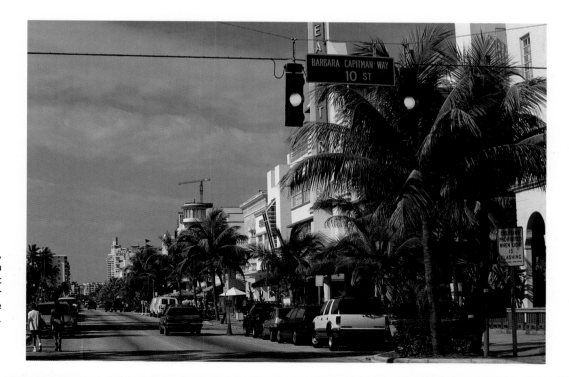

Starting from 10th and Ocean, you will find numerous eateries in most of the Ocean Drive Art Deco hotels — in either direction. Try going south one day and north the next.

As far as "cheap eats" go, you don't have to sacrifice too much. Among the oldest Cuban restaurants on the Beach is Puerto Sagua, at the corner of 7th and Collins. Everything about this place breathes authenticity. You'll find down-home Cuban food, and very little glamour. Another Cuban themed eatery within easy walking distance is "El Viajante Segundo" (never mind how it's pronounced; just look for the sign) at 1676 Collins Avenue, and Lario's at 820 Ocean Drive, founded by the famed songwriting and re-cording couple Gloria and Emilio Estefan. Because Lario's is located in the heart of Ocean Drive, you'll pay more than you will at the other Cuban establishments, but, again, Ocean Drive is Ocean Drive. If you're in the market for something within walking distance that is a little less exotic than Cuban food and also won't set you back too much *dinero*, then try ambling over to Pizza Rustica at 9th and Washington (now with a new branch on Lincoln Road as well), two blocks west of Ocean.

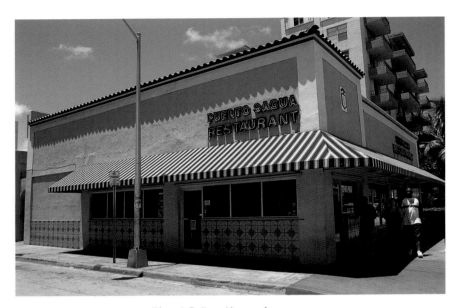

Puerto Sagua Restaurant, at 7th and Collins. Known for its down-home Cuban cuisine, not its atmosphere.

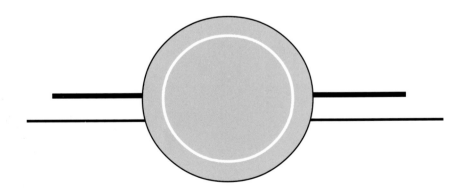

Chapter Eleven

Away From the Ocean
The Meridian Neighborhood

After lunch, of course, you'll want to extend your walking tour to work off all that good food (or, this being South Beach, you could take a nap). You're on your own for the nap, but here is another fairly substantial walk that will lead you from your starting point at 10th Street and Ocean Drive, going west, away from the ocean.

One of the nice things about managing your own South Beach tour is that you can explore some of the areas that don't show up on all the postcards and typical photos. Because the areas bordering the ocean are so brilliantly spectacular, it is easy to miss out on the delightful neighborhoods of South Beach that lie a few blocks in from the sea. A good example of one of these neighborhoods is Meridian Avenue between 10th and 16th Streets. As they say, "half the fun is getting there," and that certainly is true of this walk away from the ocean. Meridian Avenue, as the name sug-

gests, runs south-to-north more or less in the geographic center of Miami Beach. You can reach it by starting at the Art Deco Center (10th Street and Ocean Drive) and going due west for about five or six blocks.

On the way, you're going to cross Collins Avenue, which is becoming the unofficial "shopping street" of South Beach; Washington Avenue, the "club capital" of the District; and then a leafy residential area of several blocks. As you cross each major avenue, you will see sights and areas worth a detour from your westerly walk. Go ahead and explore these areas, because each will reward you with a host of Art Deco themed architecture, whether it takes the form of garden apartments, nautical-style bungalow apartments, or, in a few cases, a full-blown Art Deco hotel that is off the beaten path.

Lower Collins Avenue, between 6th and 7th street, another shopping mecca, looking south toward South Point.

Lower Collins Avenue, on the west side of the street, you'll find fancy and fun designer shops, such as Nicole Miller.

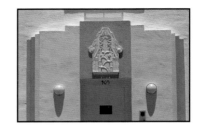

You will know that you've reached Meridian Avenue because you will see that, across the street and to your right, in a northerly direction, there is a large park that runs along the west side of the street. This is Flamingo Park, which is more or less the "Central Park" of South Beach, and is often used by locals for sports and recreation. Probably because Flamingo Park provides such a pleasingly green and recreational vista, the structures along the east side of Meridian, across the street from the Park, tend to be especially attractive and well maintained. A great example of this kind of hidden gem is the Flamingo Plaza, at 1051 Meridian. This is one of the neighborhoods of South Beach that is best discovered on your own, in the sense that, while there are no must-see landmarks among the dozens of picturesque buildings, the scene as a whole is of a rolling guidebook of Art Deco styles on a small scale. Needless to say, unlike much of the rest of the District, this east side of Meridian across from Flamingo Park, is calm and unhurried, and you're likely to be the only Art Deco-watching group in the area at any given time.

Once you've reached about 16th Street, you've left Flamingo Park behind and you've entered the Lincoln Road area. Lincoln Road is worthy of (and will receive) its own chapter of this book. During your "Meridian Neighborhood" walking tour, I suggest that you turn back east at about 15th Street and zigzag up and down the avenues (Euclid and Pennsylvania and Jefferson) and back and forth on the streets between 15th and 11th, to create your own tour of this charming but often over-looked part of South Beach. In no time, you'll be the world's greatest expert on the route that you create.

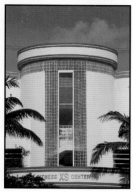

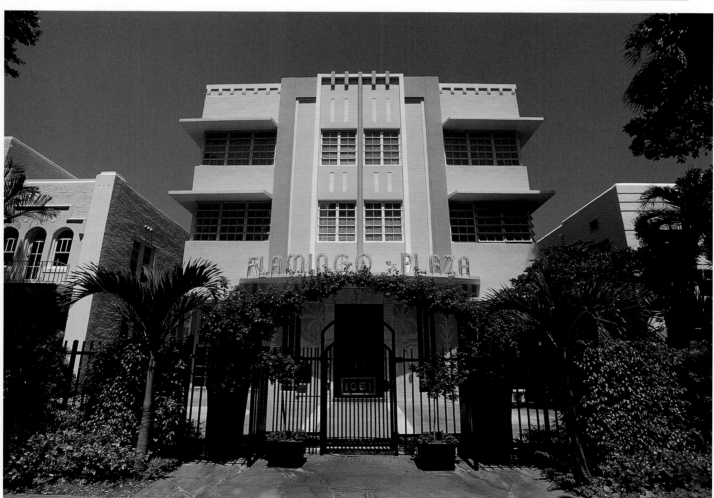

Flamingo Plaza, 1051 Meridian Avenue. Art Deco gems like this one can be found throughout the residential district west of Washington Avenue.

Chapter 12

Getting "Cool" on a Hot Beach Day

The Ritz and Other Watering Holes by the Sea

Don't believe that you can't take in the special character of South Beach if you spend too much time on the beach itself. Yes, the sand and sun are not unique to South Beach. But when you add in the social life that is waiting for you along that beach, you have a very special flavor in your sand and surf diet. Strolling along the beach north from your starting point at 10th and Ocean Drive, you will see that some of the hotels and other establishments along the beach open their arms to the casual visitor thirsty for a break from the simple pleasures of the shore.

You will need to be a little selective to make the most of this tour, because some of the hotels are not very welcoming to any but their own guests (which is a mistake in my view, but I guess they think that the "exclusivity" element is important for their particular clientele). But, never fear, some of the "coolest" places along the sand are also more than happy to have you drop by and sample the sophisticated pleasures that they have to offer. One of these is the relatively new Ritz-Carlton, located at the east end of Lincoln Road (which is really 16.5 Street), on the beach. I recently stopped into their beachside bar and lounge area (called the Dilido Beach Club Restaurant, after the older hotel structure that has been incorporated into the new hotel) with my nephew – who is a rather sophisticated New York Designer. He commented on how he could not believe that a Ritz-Carlton (normally known for its special appeal to the upper classes) actually welcomed the beachcomber on foot and maintained such a "cool space." You can have some of the fanciest and most delicious drinks and food right here at the edge of the sandy beach. You may save a few more dollars at the other seaside stops mentioned later, but you'll save a few more steps here as this one is in South Beach, and very glamorous, considering you can come as you are — wet bathing suit, wet hair, sandy feet…whatever.

Another beachside delight that can easily be reached from your starting point at 10th and Ocean is the Riande

Continental Hotel in the 1800 block of Collins. They will fill your tummy with good fare and cocktails in a nice outdoor setting; however, the pool is off limits, reserved for only their guests, which is the understandable rule of all the hotels in Miami Beach. If the security guard should stop you at the Riande, simply state that you're there for lunch or a drink, and you will be admitted with no problem.

A few beach blocks later you'll come upon our wooden boardwalk, which runs from 21 Street north to 47th Street (lots more lifeguard stations to see if you have the stamina). When you reach 30th Street you can stop at The Palms Hotel where you may exit onto their grounds and have a nice outdoor lunch or a drink at their bar. A few steps later, going north, you'll come to the RIU Florida Beach Hotel. There too you can leave the boardwalk and enjoy their breakfast, lunch or dinner, depending upon your time of arrival.

Further up the beach (in the forties), there are side-by-side architectural gems by the late Miami Beach master architect Morris Lapidus. You've no doubt heard about these two famous (and sometimes feuding) hotels — the Eden Roc and the Fontainebleau. What's most important for our purposes about these Miami Beach institutions is that you can partake of their beautiful and sophisticated grounds and goodies right off the beach. At the Eden Roc, located at the north end of the elevated wooden boardwalk that runs all the way from South Beach to 46th St., there is a beautifully located eatery currently called "Aquatica." Here, you can stop by for a burger and salad while watching the surf roll in and getting a tan (be careful, though, the Florida sun can be deceptively strong). Lunch (with a glass of wine thrown in) will run you about $25 per person. The view is free. At the Fontainebleau, there are more restrictions on visits by non-hotel guests, but you can still partake of its beachside burger and fries eatery if you want to take a rest from your beachcombing at this famous Miami Beach landmark.

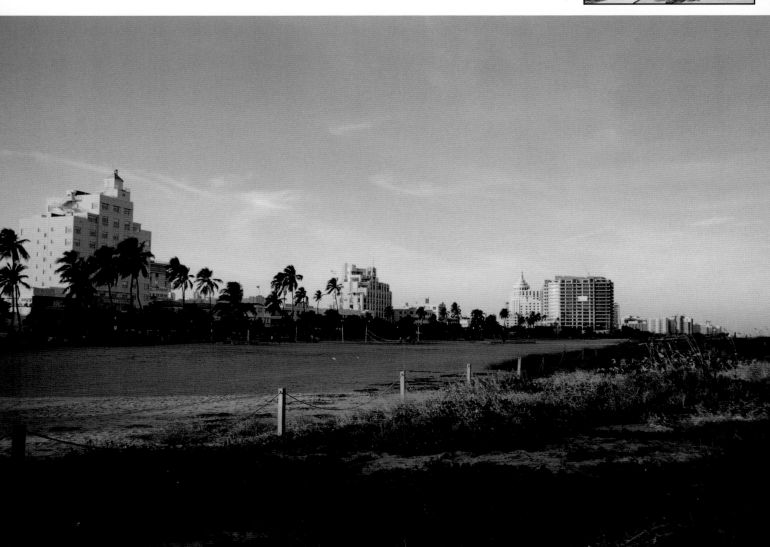

Heading north, beachside, toward the newest and the largest of South Beach hotels, The Loews and The Ritz-Carlton.

Chapter Thirteen
In the Swim
South Beach Style

With all that beautiful water at your beck and call in the turquoise Atlantic, you might think that the "swimming pool" might be a rare find in South Beach. Actually, you'd be wrong. In fact, some of the world's most beautiful pools (really, they've won awards and everything) are there for the bathing in Miami Beach (at least if you know someone in management or, even better, are a guest at the hotel). Called "the most beautiful pool in the world" in the pages of *LIFE Magazine* (1947), the pool at the Raleigh Hotel (Collins and 18th St.) is worth making a special effort to see and be seen at. As in so many other South Beach locales, though, don't show up here if you have moral objections to women in VERY skimpy bathing suits – many of them what you could call a one-piece version of a two-piece suit. On the other hand, DO show up here if you're interested in some awfully haute cuisine at less-then-haute prices at the eatery which overlooks the Raleigh Pool.

I mention the part about the Raleigh's scantily-clad pool population because, in my experience as the Resident Artist of the Art Deco Welcome Center, I occasionally still run into people (almost always women) who seem shocked — SHOCKED! – to be confronted by one or another of the "anything goes" areas of the beach itself or at the hotels. The most amusing of these episodes occurred just recently when an otherwise average looking female in her twenties came crashing into the Welcome Center shop in a state of spluttering indignation.

The first words out of her mouth were "Isn't there a beach around here where people are required to wear clothes?"

Basically, the answer here on South Beach is "Whatever."

But, because she seemed so genuinely upset, I did my best, patiently explaining that we have a lot of sophisticated European and Latin American vacationers here; and so things like beach-dress customs have become flexible enough to make those vacationers feel at home. Well, my visitor thought that it was all just "disgusting;" and it was just as she uttered that

word "disgusting" that I saw her husband standing at the doorway to the store, looking at me apologetically and very disappointed that his wife was making a big deal about our lack of dress codes.

In any event, the Raleigh Hotel pool scene is one of many in South Beach that you want to get invited to. Among the others are the Delano Hotel (Collins Ave. and 17th Street), which is only one block from the Raleigh. The Delano is worth a visit whether you're going for the pool, lunch or just to gawk at the endless parade of amazingly attractive people wandering around the east-west passageway that makes up most of the Delano's lobby floor. While you're at it, see if you can wangle an invitation to the roof-level pool at the Tides Hotel (Ocean Drive between 12th and 13th Streets). One of my favorite memories of the Tides pool is that, the last time I was there, I saw a sign that read: "Topless swimming attire is permitted; complete nudity is discouraged." About the only thing you need to know about the South Beach attitude to life is that, even at the finest hotels, it's pretty laid back.

The Raleigh Pool at 17th and Collins. Go for the banana French toast at breakfast (before 11:00 am). Viewing the pool while eating breakfast is a special treat.

Chapter Fourteen
Lincoln Road
Where Locals-in-the-Know Go

Three blocks west and six and a half blocks north of 10th and Ocean Drive is one of the most delightful pedestrian promenades outside of Europe. It is generically called "Lincoln Road," after the pedestrian-only thoroughfare that starts just west of Washington Ave. between 16th and 17th Streets. You can get an idea of its Art Deco years in the 420 Lincoln Road building (just west of Washington), with its curved corners beckoning you to nestle between and enter the main door at the center of the building. It's also worth a peek inside this building at the beautiful mural in the lobby.

Lincoln Road has gone through a lot of history, reflecting the architectural, social, and economic history of all of "old" Miami Beach.

Mercantile Bank building, Albert Anis, 1940. Step inside to see the murals.

Looking east on Lincoln Road in the 1930s, when cars were allowed to drive on what is now a pedestrian-only thoroughfare. Postcard, Tichnor Bros., Inc.

On Lincoln Road, you will see sights like the old 1930s-design Cadillac dealership with the original (and long buried under layers of less distinction) Deco style "Cadillac" and "LaSalle" insignia built into the masonry design of the building itself. (The LaSalle, by the way, was a General Motors automobile line that was produced during the Art Deco era and was cancelled by GM, mostly because it began to outsell its older — and more expensive — Cadillac siblings.) This beautiful piece of Thirties architecture now houses one of Miami Beach's leading twenty-four-hour bars and eating establishments. Its name is "Cafeteria," period. Not "The Cafeteria," but just "Cafeteria;" it is the southern outpost of a NYC bistro by the same name. It is reasonably priced, though don't confuse this with literally cafeteria-style food. The food here is MUCH better than you could ever hope for in a real cafeteria: and the style? Well, the style is neat; cool; hip; groovy — whatever adjective your particular generation of "in-crowd" people might prefer to use.

Intersection of Pennsylvania Avenue and Lincoln Road.

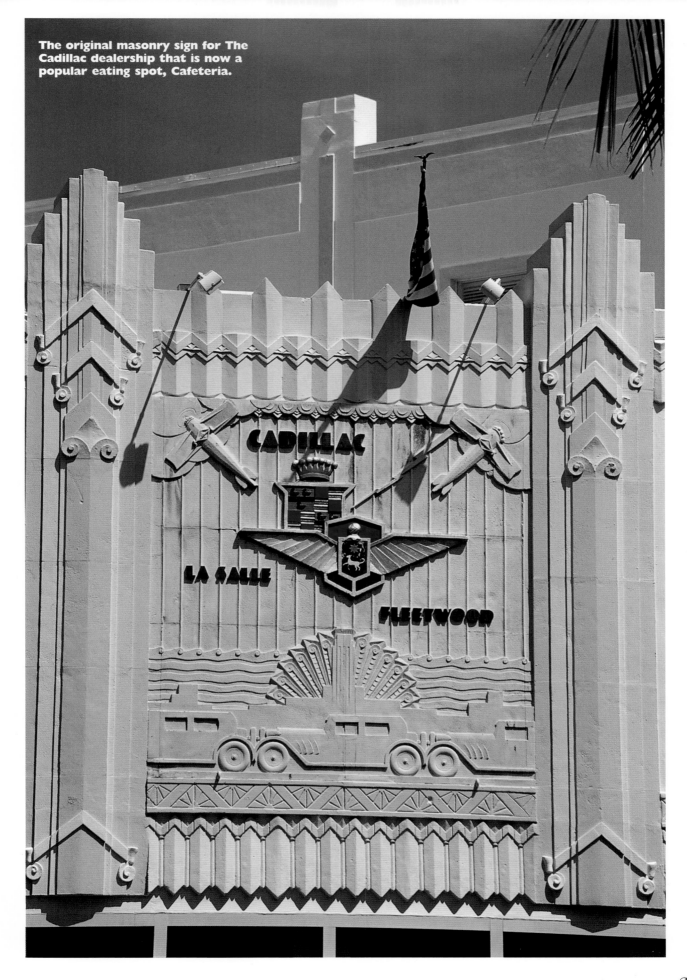

The original masonry sign for The Cadillac dealership that is now a popular eating spot, Cafeteria.

CADILLAC

LA SALLE

FLEETWOOD

Across "The Road" from Cafeteria (at 555 Lincoln Road) is the beautiful Lincoln Theatre, which was once a cinema but now houses live performances, including those of the New World Symphony, one of Miami Beach's proudest cultural possessions.

One of the quirky and delightful things about Lincoln Road is that it is, at one and the same time, one of the most fashionable and one of the most "laid-back" spots in the world. There's a Bohemian element to the Lincoln Road "scene" that is missing from the glitz of Ocean Drive and the all-out sexiness of Washington-Avenue-at-night. An example of Lincoln Road's unique mix is that it hosts the only longstanding, serious bookstore in South Beach. Okay – so, like most people, you didn't come here to complete your education or even catch up on your reading (though there are few daytime activities as escapist as a good read at one of South Beach's cafes or out on the sand itself). But there is something about a neighborhood bookstore, particularly this neighborhood bookstore, that will enrich your experience in Miami Beach. The place is called "Books and Books," and it has been on Lincoln Road since before the post-1990 renaissance. It is definitely worth a browse, especially during a morning walk, because the proprietors have been wise enough to include a window-and-sidewalk café in the establishment. Have a coffee while browsing the latest best-seller or the latest celebrity news items.

Lincoln Theatre, 541 Lincoln Rd.

Before or after your visit to Books and Books, take a moment (or an hour) to explore and appreciate the special building that houses it. It is called the Sterling Building, and it has an interesting story to tell. It was originally built as two mostly Mediterranean style structures in 1928, but was redesigned in 1941. The redesign had the effect of joining the structure at the second story, which spans what had previously been the space between the two original buildings. Go into that space, and, depending on when you visit, you may find a club, restaurant or courtyard beyond. Remember, "hotspots" come and go pretty quickly in South Beach.

The oh-so-beautiful Sterling Building, originally built in 1928, but got its Art Deco style from its 1941 revamping and renovation by Nellenbogen. Books and Books has been housed in this beauty for many years.

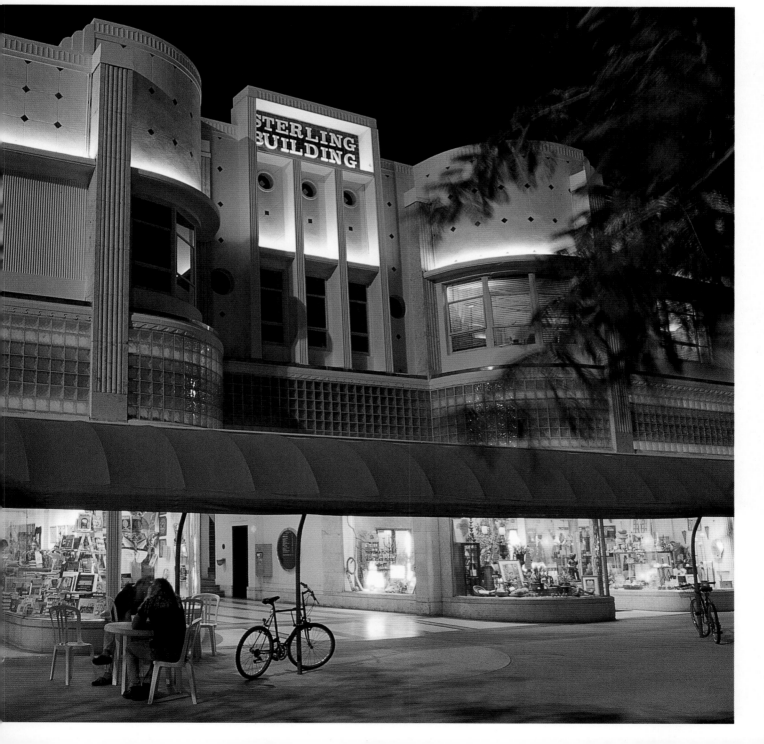

You can also see a nice example of Mediterranean architecture at the corner of Lincoln Road and Jefferson Ave., now occupied by the Van Dyke Café and Jazz Club. An entirely different kind of place from Cafeteria (but also cool, like Cafeteria), it is owned and operated by the same folks who founded and still run The News Café (see page 39), and the menu is largely the same. This is definitely one of the best spots on "The Road" for people-watching of all types. Generally speaking, by the way, locals will refer to Lincoln Road as, simply, "The Road." But in Miami Beach, as opposed to, say, Los Angeles, it really isn't important that you know what the locals do; and the locals tend to be happy no matter what you call their streets. It's cool to be a tourist in Miami Beach. So many of us who live here started out that way.

Intersection of Jefferson Avenue and Lincoln Road.

The Van Dyke Café and Jazz Club, 846 Lincoln Rd…check out the telephone booth around the corner on Jefferson.

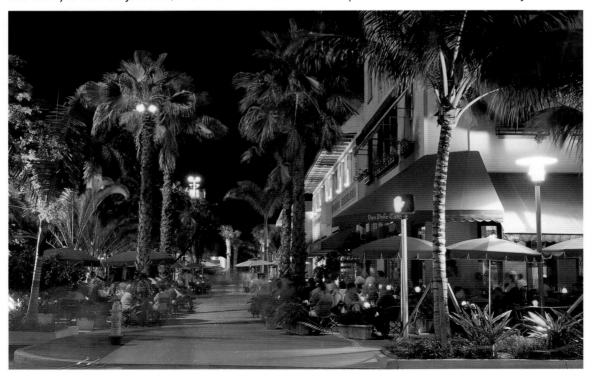

But Lincoln Road has a lot more to offer than just restaurants and cafés. There's an ever-changing and uber-hip selection of one-of-a-kind boutiques and cosmetic/beauty emporiums. While a number of "big-box" national chain type stores have recently invaded the western end of The Road, they fit in much better than most locals had earlier feared (the sexy posters in the Victoria's Secret windows fit in especially well). By and large, there are enough small spaces, and enough turnover in the occupants of those spaces, that Lincoln Road is the place that most locals will visit when they want a dose of South Beach shopping for themselves. There are shoe stores aplenty, with everything looking stylishly Italian but some of it coming (at lower prices) from Spain, Brazil, and Eastern Europe. There are also more-flamboyant-than-usual women's specialty shops featuring very edgy designs, and a few shops that cater just to men, both gay and straight men with a sense of personal style. You won't find any gray-flannel suit type places on Lincoln Road, and nothing is absurdly expensive. You can go a few miles up Collins Avenue to Bal Harbour for that. But it is certainly worth browsing the shops while you're strolling and selecting a sidewalk café to stop at for an extended bout of people-watching under the palms. By the way, you can also get very good Cuban coffee right on The Road (at The Lincoln Road Café, 941 Lincoln).

Along with all this exciting one-of-a-kind flavor in its boutiques, Lincoln Road has, for some years, been hosting a variety of outdoor markets and open-air festivals. Every two weeks during the season, you can count on there being an antiques market here, lining the space between the shops and the middle of The Road. There are several dealers who know something about the Deco styles of the 1930s, '40s and '50s, and carry furniture and other objects that will make you feel you've stepped back in time to a simpler and more graceful era. There's everything from costume jewelry to old books and magazines, and the discerning eye can usually find a few treasures on any given afternoon (once every two weeks, that is) on The Road.

Beside the every-other-week antiques market, there is a dependable weekly Sunday food and flower market here. Because of its relative proximity to Latin America (both geographically and spiritually), Miami and the Miami area have access to an astonishing array of tropical and other exotic flowers and foliage at amazingly low prices. Forget about red roses at $60 a dozen. Along The Road, they're going to be about $10 a dozen, maybe less if you can hold off until twilight. Twilight is when a lot of the flower dealers will typically dump whatever inventory they have left for whatever they can get just before closing time. But the varieties go way beyond roses, including an astonishing number and range of orchids and tropical flora that probably would not travel well to a colder clime but are a lovely amenity during a week's stay in your Miami Beach hotel room.

And, finally, there is a respectable "farmer's market" type market that operates each Sunday as well along Lincoln Road. One of the most surprising things about the Miami area is how much agricultural land there is just a dozen or so miles away from South Beach. Along with some imposters, no doubt, these farmers show up in force along The Road to tempt you with everything from mangos (yes, there is a crop that is grown right in South Florida and ripens during the summer months) to green beans, from native tomatoes to in-season oranges and cantaloupes during the winter. Cheeses and breads too, of course, and all while scoping out a walker's paradise with the most exotic looking people in the world.

But the regularly scheduled outdoor events are not the only parties on the Lincoln Road roster of festivities. One other "traditional" event is worthy of special mention and a special effort to attend if the dates of your trip to South Beach make it possible for you to do so. For some reason (thank goodness), great looking people are attracted to Halloween on Lincoln Road. The bottom line is that if you can be here or get here for Halloween on Lincoln Road, you'll never want to be anywhere else again at the end of October – and not just because it's likely to be seventy degrees Fahrenheit.

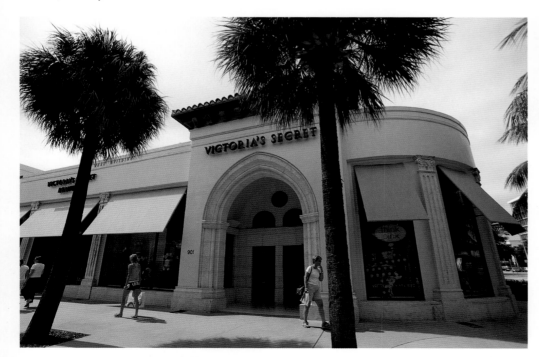

Victoria's Secret, 901 Lincoln Road.

At the west end of "The Road" is the Colony Theater, at 1040 Lincoln. This structure is, at this writing, in the final stages of renovation and should be quite a jewel when it is completed.

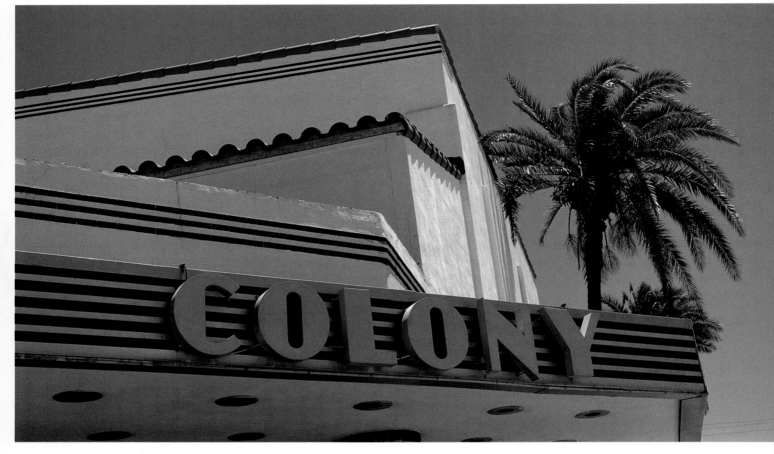

Colony Theatre, built in 1934, and at this writing being restored to its original beauty.

Even farther west, at Lincoln and Alton, is the Regal Cinema Building. This building is yet another example of a structure that purists may hate but, I think, works because it is an obvious attempt at whimsy and "look-at-me" (not unlike South Beach generally). It's also about the only place to go if you've got one of those delicious, old-fashioned "movie days" on your hands during your South Beach vacation.

Right, above:
The Lincoln Center Movie Theatre complex, a recent addition to Lincoln Road, offering movies, popcorn, and a cool café that offers a view overlooking much of South Beach. I refer to this nautical and streamlined design as "Modern Day Deco," but you can name it anything you want.

Right:
Lincoln Center where Lincoln Road and Alton Road converge (the west end of the Lincoln Road Promenade).

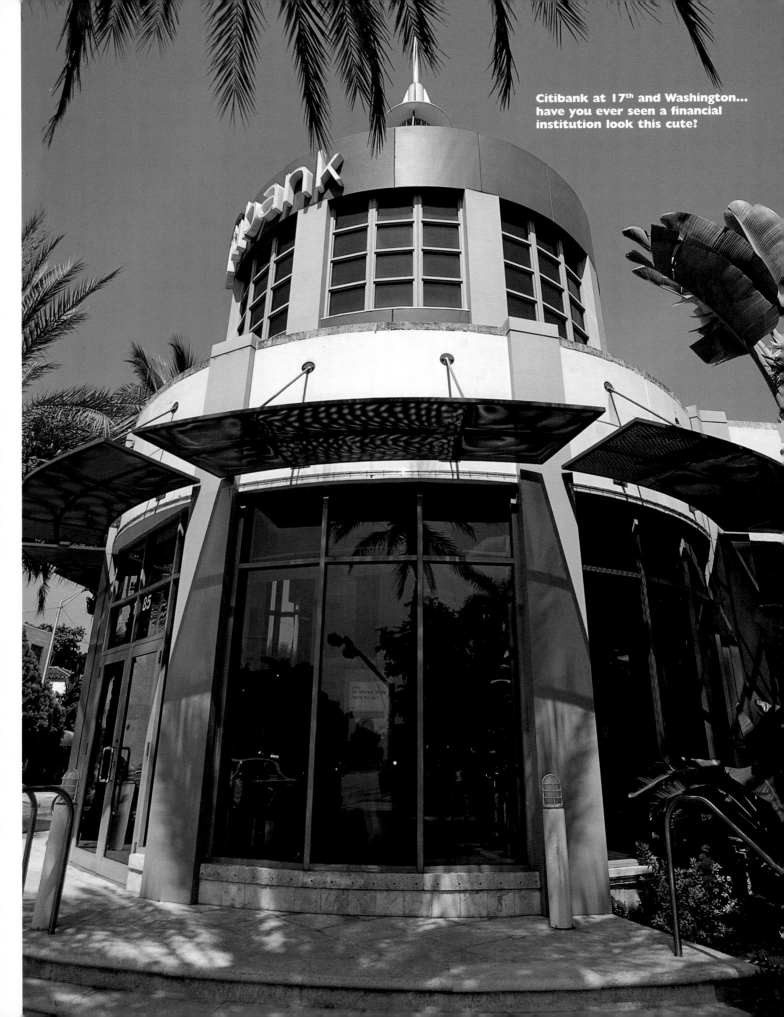

Citibank at 17th and Washington... have you ever seen a financial institution look this cute?

While I'm referring to "whimsical" styles in the Lincoln Road area, there are a few other sights to know about and see to the north of Lincoln Road along Washington Avenue. The almost new CitiBank South Beach building at 17th and Washington is, one would think, supposed to be "just a bank" — respectable, boring, and highly air-conditioned. But to the great credit of its designer, Dana Lodin, it has a number of whimsical architectural touches to it, and it was even built with a special ATM location to serve roller-bladers, who abound in South Beach.

Catty-corner from the bank is the Jackie Gleason Theater, just above 17th and Washington and sporting a 1990s constructed façade, which is successful as a sort of "cartoon Deco." Across the street from the Gleason is the Temple Emanu-El building (see photo on page 19), which is notable as an example of Egyptian Deco.

Jackie Gleason Theatre of The Performing Arts, 1700 Washington Avenue. The Jackie Gleason Show was televised from this spot…"to the moon."

To the north of the Gleason Theater is a building that a lot of guidebooks like this would tell you to stay away from. This is the Miami Beach Convention Center, of all things; but it's not just a blocky building without many windows (though it is that). It is also a building with an attempt at Art Deco detailing, mixed with a certain tendency toward creating gargoyle-type shapes. In any event, it's noteworthy in the way a lot of South Beach is noteworthy. It's a plaything along with a functional entity, like the city itself.

A lot less playful and more significant part of Miami Beach's special history is the Holocaust Memorial at Meridian Avenue and Dade Boulevard. This is yet another of the Beach's controversial architectural statements, but it is certainly dramatic to see. It is a massive, upward-thrusting hand, seemingly reaching out for God, with multitudes of victimized humanity clinging as it reaches for the sky. Is it dramatic? – or just "grotesque," as some observers have called it. Whatever it is, it echoes South Beach itself – demanding to be seen.

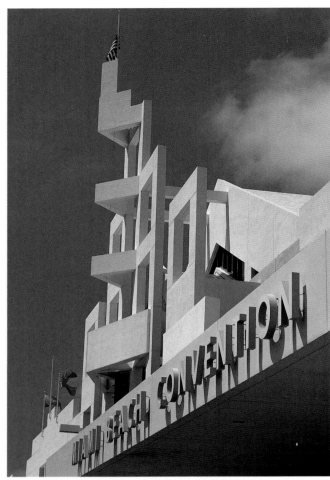

Miami Beach Convention Center, 1901 Convention Center Drive (if you're in the market for a yacht, stop by during the annual boat show).

Holocaust Memorial.

Holocaust Memorial, 1933 Meridian Avenue.

Art Deco Spots You Shouldn't Miss

By this point in the book, you have probably already concluded (correctly) that the author has a weakness for the self-discovered gem, for the kind of sight that you see, or place that you find, just because it's around a corner you happen to turn, rather than being on anyone's tour "list." Even though I highly prefer and recommend this method as the best method for appreciating fully the sights that you see, I also have to recognize its one great weakness: you might, for lack of outside guidance, miss something that you shouldn't miss. So, in an effort not to let you down, here is a listing and short description of other specific buildings and spots which make South Beach the world capital of Tropical Deco:

The WPA Post Office at Washington Avenue and 13th Street

This structure is an almost "pure" example of the kind of architecture fostered during the Works Progress Administration (WPA) days of the 1930s. The WPA was one way that the Roosevelt Administration tried to pump resources into the American economy during the terrible days of the Thirties Great Depression. And the design and construction of governmental facilities like post office buildings was an obvious area in which the government could act directly and vigorously. The exterior is superior to the interior, especially since the fountain in the lobby area is not routinely in operation at this writing. Definitely worth planning a route around, especially if you need stamps.

United States Post Office,
Washington Avenue at 13th street.

The "Diner" at 11th and Washington Avenue (see photo on page 21)

This stainless-steel structure was built in Wilkes-Barre, Pennsylvania in 1948 and actually moved here during the South Beach renaissance. It was reconstructed piece-by-piece and is easy to visit anytime of the day or night, since it never closes. The food is, well, "diner food."

The FIU-Wolfsonian Museum at 10th Street and Washington Avenue (see photo on page 19)

This institution is housed in a former storage facility (how times have changed!) that was built in 1926 smack in the middle of what now is the hot South Beach Historic (and real estate) District. It is worth an interior tour, not only because of the striking high-ceilinged entry hall, but also because it tends to mount some of the most thoughtful and interesting exhibits of "propaganda art" as well as period-specific industrial design (Tel. 305-531-1001).

The Chase Federal Savings & Loan Building at 1100 Lincoln Road

This is an example of "recycling" an Art Deco design so that an interior space is repurposed for the new century. It is the conversion of a former Lincoln Road bank done by the Banana Republic clothing chain. This conversion is one of the more successful endings for a struggle that has been repeated on Lincoln Road (and other locales in South Beach) since the beginning of this twenty-first century: "The Invasion of Big-Box Stores." This specter has horrified some of the preservationists who did so much to bring South Beach back from the dead. What Banana Republic has cleverly done, though, is to use the former bank lobby space of the old (1947) Chase Federal Savings & Loan building to build a retail clothing shop. The stands that once held deposit slips now hold displays of blouses and shirts, and the vault that once saw the comings and goings of Miami Beach wealth now witnesses a parade of shoppers trying things on for size, because it has been repurposed into a unique set of fitting rooms. Definitely worth a visit, even if you're not in the market for some new duds.

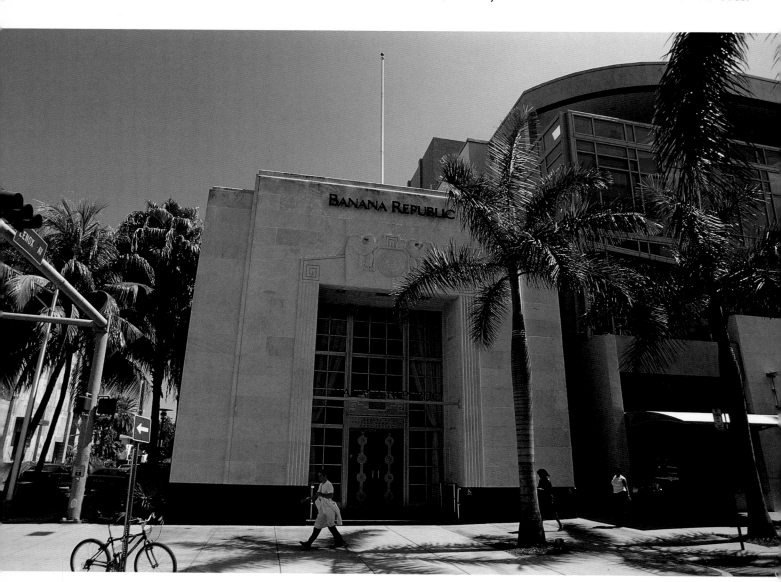

Banana Republic (formerly Chase Federal Savings and Loan) 1100 Lincoln Road.

Bass Museum of Art at 2121 Park Avenue

Originally built in 1930, the structure housing this leading Miami Beach museum was a library for a large part of its life until becoming a museum in the 1960s. The Museum is worth visiting as either an Art Deco structure or as a Museum. It has gained a reputation in recent years for its surprisingly big-city gallery exhibitions. To find it, go to the same area as the current public library at 22nd and Collins, and look for the Bass Museum behind the library (Tel. 305-673-7533).

Bass Museum of Art, 2121 Park Avenue.

Chapter Sixteen

Not Art Deco
But Worth a Walk

South Beach has become famous largely on the strength of its unique subset of the Art Deco style. But there are other walking tours that are worth taking even though the rewards aren't, strictly speaking, "Deco." You can, for instance, walk a few blocks north and west of your starting point at 10th and Ocean Drive and see several important and fascinating landmarks. Among the most spectacular of these are the unique buildings that lie along Española Way between Washington Avenue and Drexel. This area is entirely unlike any other area in South Beach in that its architecture is consistent and is made up of several fine examples of the Mediterranean Revival style that was influential in the 1920s. Desi Arnaz, of the famed television series "I Love Lucy," threw some wild and crazy parties here during the early 1940s. He crooned his Cuban songs and played his bongos until the wee-hours. You can't miss Española Way as you're walking north on Washington Avenue, having just passed 15th Street. You'll see what you think is a slice of Old San Juan or, perhaps, some Spanish village on the Mediterranean coast. In actuality, Española Way is yet another of the set-piece neighborhoods that has shared in the renaissance of South Beach brought about by Barbara Capitman and the Miami Design Preservation League.

It's worth visiting Española Way with enough time to sit and enjoy the beautiful surroundings while having a drink at one of the many outdoor cafes that line this block. Or, if you have a shopper's streak in you, you might want to wait until your first weekend in South Beach, since that is the time that Española Way turns itself into a pedestrian-only plaza with vendors lining each side of the street selling every sort of funky item. There are also art galleries and clothing shops on Española Way.

Espanola Way, with
banners advertising its
Weekend Market Days.

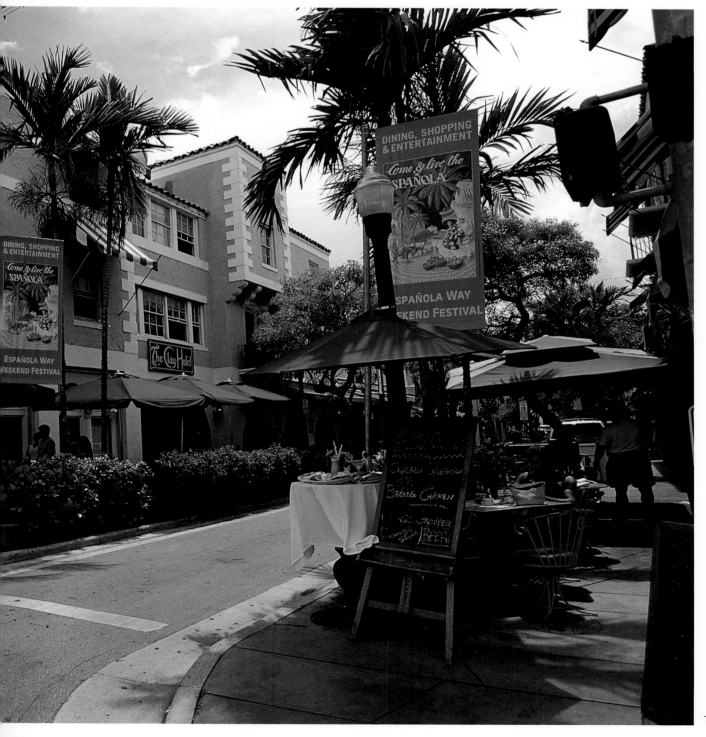

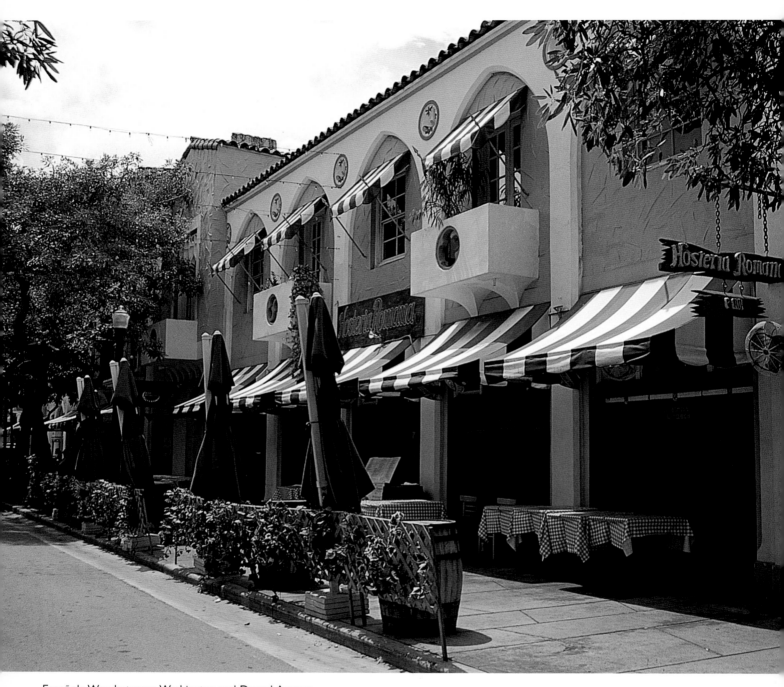

Española Way, between Washington and Drexel Avenue.

➤

A doorway leading to somewhere
mysterious on Espanola Way.

A few blocks north and east of Espanola Way (at Collins Avenue and 22nd Street, to be precise), you'll see a turret-like structure that has become known as "The Rotunda." It is actually part of the structure of South Beach's public library. Should you need a pause, this library is a perfect stopping point where you can thumb through some magazines and books and, at the same time, check out its uniquely shaped rotunda section, which is as interesting from the inside as it is from the exterior.

Miami Beach Library Rotunda, 22nd and Collins Avenue.

No walking tour of non-Deco sights would be complete, of course, without seeing the Casa Casuarina on Ocean Drive at 11th Street – just one block north of the Art Deco Center. This structure is another beautiful example of Mediterranean Revival architecture, but more interestingly, it has had its own colorful history. It was built in 1930 (from plans going back to Christopher Columbus' son) as a winter getaway for a wealthy oil executive, and renamed "The Amsterdam Palace" in 1935. It was renamed by its developer after...himself. This is not entirely surprising, since, as noted previously in this guide, there is no shortage of self-absorption in the air of South Beach. In any event, this gentleman's name was Jac Amsterdam; so the building was named "The Amsterdam Palace."

Casa Casuarina (where Versace lived and died).

MAUI DESIGN PRESERVATION
1001 OCEAN DRIVE
MIAMI BEACH FL 33139
305-672-2014

Merchant ID: 543469388101816
Term ID: 0404

Sale

MASTERCARD

XXXXXXXXXXXXX5212

Entry Method: Swiped
Apprvd: Online Batch#: 000007
07/18/08 17:00:58

Inv#: 0000009 Appr Code: 045382

Total: $ 26.70

Customer Copy

THANK YOU!

Even more interestingly, just as South Beach was awakening from its long stupor during the 1970s and 1980s, this gorgeous building was noticed by none other than the famous Italian fashion designer Gianni Versace. Versace, who had visited and fallen in love with South Beach, purchased the Amsterdam Palace with the idea, beautifully realized, of converting it into his very own mansion-by-the-sea. And that's exactly what he did. He renovated the old Amsterdam Palace structure and (after some negotiating with the Miami Design Preservation League) added on to it by purchasing the 1950s-era hotel next door. He tore down the hotel (which, all but the most hardened preservationist will admit, wasn't such a great piece of architecture) and expanded his property to the south. The result is what you can see today. Today it is known simply by its original name, "Casa Casuarina."

But, whatever its name, the Casa Casuarina is still most prized by visitors to South Beach as sort of a memorial to Versace, who was murdered on its front steps by a deranged serial killer in 1997. Prior to his murder, Versace had become a very important element of the gathering South Beach renaissance of the 1990s, since he brought a taste of European sophistication and glamour to the area even as it was awakening from its worst years. The fact that such a leading light of fashion lived – and died – here has resulted in a phenomenon that you can still see today: little knots of visitors pausing and posing on the steps where Versace was gunned down to have their picture taken against the backdrop of his beloved mansion. Some people think that this sort of fascination is a bit odd, even macabre, but, like it or not, it is part of what South Beach has come to stand for.

Many traditional South Beach purists would argue against highlighting any building that isn't at least fifty years old, but the truth is that there have been a number of very recent architectural designs that will certainly become landmarks for future visitors. And part of their success is that they have either integrated older structures because of the influence of the Miami Design Preservation League and other preservationists; or they have successfully captured the "madcap mood" of South Beach, and thereby sparked a whole new generation of characteristic structures. So why not get a head start and see them now? The South Beach Marriott, at 161 Ocean Drive, is one such example (see photo on page __). The developers were required by the city to preserve certain pre-existing structures when they built this hotel in the 1990s, and the result is very handsome and successful – especially for a Marriott, which is not generally known as an architectural leader in the hotel industry. It is also very beautifully done in the interior, and, like just about any hostelry, should be happy to welcome you inside for a look around.

Another successful design of the 1990s is the Loews South Beach Hotel (see photo on page 55), a massive new convention hotel that sits at Collins and 16th Street. While the building is criticized by some for its vault-like density, the architect included a characteristically Deco turret at its most prominent corner and rounded that corner, much in the way of the Art Deco architects who worked nearby in the 1930s and 1940s. The Loews also incorporated the old St. Moritz Hotel structure as a sort of "outbuilding" next to the new facility.

The Gianni Versace logo that embellishes the ironwork fences surrounding the grounds of Casa Casuarina.

➢
The Michael Graves complex at the northern end of Ocean Drive at 15th street.

Another category entirely is the kind of high-quality new development that is epitomized by the cluster of buildings you can see as you look north on Ocean Drive toward 15th Street. Because of a quirk in the city's residential planning, the restriction against building on the beach side of Ocean Drive did not prevent new construction during the 1990s and early 2000s at this northernmost terminus of Ocean Drive. While many Miami Beach preservationists (including the author) were upset at the prospect of obstructing more of South Beach's signature strip of sand, the developers have created a sort of "Early Twenty-first Century Cluster" here that I now suspect will become a valued landmark in its own right. Two of the buildings in this cluster of shapes and colors were entirely new: The building that houses "Il Villagio," a very high-quality residential property that also encompasses retail shops; and the Michael Graves-inspired 1500 Ocean Drive complex, again including commercial space and of similarly high quality.

Peeking out behind the combined visual of Il Villagio and 1500 Ocean are shapes that belong to the Royal Palm Hotel. The Royal Palm, which fronts at 1545 Collins and was originally designed in 1939, is noteworthy simply because it is not so much a preservation of an Art Deco era structure as a re-creation of it. As in many other iconic South Beach structures, the concrete in the original Royal Palm construction had, over the years, been compromised by the relentless encroachment of salt air. Experts and preservationist partisans differ on whether this condition was caused by the natural processes at work when living by the sea or, more ominously, by a politically-inspired (and perhaps corrupt) compromise in the concrete standards during the boom times of the 1930s and 1940s. Put otherwise, a few city officials of the Deco era in Miami Beach may have been tempted to take bribes and "look the other way" when it came time to assure that the sand mixed into the concrete of the day was, in fact, worthy of being used for construction.

In any event, when it came time to convert the Royal Palm into a modern 1990s hotel (specially dedicated to serving the African American clientele that had traditionally been underserved on Miami Beach), the owners were faced with the requirement to preserve an original structure that was crumbling under its own weight. The solution? A very painstaking, costly, and time-consuming re-creation of the 1939 original that went hand-in-hand with the building of the new modern shapes that you can see peeking out behind the Il Villagio and 1500 Ocean buildings at the north end of Ocean Drive.

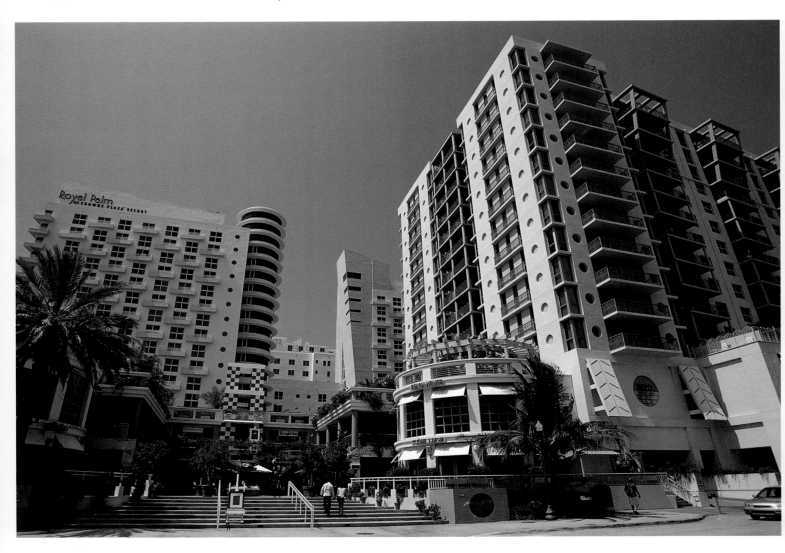

Chapter Seventeen

Dinner

The Reward for a Hard Day's Pleasure

Along with all the other delights of your South Beach walking tours is the opportunity to pass a restaurant that looks like just the right spot to return to for dinner. During the really busy tourist season, in fact, it is a good idea to consider making a reservation during the day for the meal that you want to have at the place you want to have it that night – particularly if the "feel" of the place seems right to you during your daylight walks.

But, whether you include your choice of dinner habitat as one of your daytime goals or not, you want to at least THINK about breaking out of the McDonald's / Taco Bell / Olive Garden / Chili's circuit that most of us spend our mealtimes on. Why? Well, the first answer that many of you come up with may be the opportunity to taste "Latin" food. And, you're right; that opportunity is here in abundance. But the kind of food that qualifies as "Latin" in South Beach is quite different from the "Tex-Mex" standard that most of us are used to. While the Latin American influence IS strong in Miami Beach (obvious to anyone who hears people speaking on the street), there is almost no Mexican influence. The Latinos who live here (some of whom will prefer to be called "Hispanic") are going to be from most any Spanish or Portuguese-speaking country in either hemisphere – Cubans, of course, but also many natives of Colombia, Argentina, Brazil, Venezuela, Peru, Puerto Rico, Nicaragua, Honduras, Chile, Costa Rica, and El Salvador. Yes, there are also immigrants from Mexico (and Mexican-Americans) who live here, but the Mexican influence as THE Latin influence is not much in evidence here.

Having said that, there are some good Mexican restaurants in South Beach, one of the best being El Rancho Grande, which is located just off of Lincoln Road (at 1626 Pennsylvania Ave.) and can therefore be easily surveyed during one of your daily walking tours. Other types of Latin American restaurants, including endless little Cuban corner cafes, more elaborate Colombian eateries, and many Argentine and Brazilian restaurants are almost impossible NOT to bump into during any good day's walking adventure.

As varied as the Latin eating experience can be in South Beach, it is only the beginning. Miami Beach has a more

than respectable supply of sushi restaurants, for example, with many of the local fish being as fresh as you can get anywhere. The number of true Italian restaurants (as opposed to good, but not-quite-the-genuine-article, Argentine/Italian restaurants) in the area has skyrocketed along with Miami Beach's popularity as an international destination. At the time of this writing, there are almost TOO many Italian eateries lining both sides of beautiful Lincoln Road.

Larios on the Beach, Gloria and Emilio Estefan's Cuban restaurant located at 820 Ocean Drive.

And we even have our share of "new wave" American cuisine here, with "Pacific Time" on Lincoln Road as the veteran of this group, but also Nemo down at First Street and Collins and Mark's South Beach, chef Mark Militello's culinary canvas at the Nash Hotel, 1120 Collins.

Until fairly recently, one of the few shortcomings of South Beach's dining scene was the relative lack of outdoor eating spaces. With the influx of younger tourists and residents in the 1990s, however, it has become *de rigueur* for fine (and even not-so-fine) restaurants on South Beach to devote a substantial amount of space and effort to the alfresco dining experience. Some have even added outdoor heating devices for the four or five days per winter when patrons might otherwise feel a chill in the air, as well as (most recently) "misting" machines, which will help a diner forget about the high temperatures outside during summer evenings. My own preference whenever I eat at a South Beach restaurant is almost always to sit outdoors, though I know that some people prefer the more controlled environment of an interior dining room. Just remember, if you think you're indifferent to the choice of outside or inside dining, the "people-parade" is best on the outside; and the "people-parade" is better in Miami Beach than almost anywhere else on Earth.

Is there a simple alternative to "scouting out" dinner accommodations during your daytime walks or through guidebooks like this one? Here's my way: (1) If I want to see and feel all the honky-tonk, be in the midst of all of the hyper-sexy environment that South Beach has to offer (but I don't care ALL that much about the nature or quality of the food, or the price), I may well just cruise on foot along the west side of Ocean Drive until I find a posted menu, an alfresco setting, a host/hostess, or a style of food that intrigues me; (2) If I want to shift the emphasis a little more to the quality-of-food and sophistication side, I'll just make my way to Lincoln Road, where I'll find an unparalleled (on Miami Beach anyway) selection and variety of restaurants and hip cafes and not have to sacrifice much, if anything, in the way of the "people-parade," which is only marginally less outrageous on Lincoln Road than its counterpart on Ocean Drive; but (3) if I'm after a particularly fine dining experience, I would keep track of the current crop of fine-dining restaurants — among them, at this writing, "Wish," the restaurant at "The Hotel" (previously called and still locally known as The Tiffany Hotel), Pacific Time on Lincoln Road, Casa Tua on 17th Street between Collins and Washington, The Restaurant at The Raleigh (18th and Collins), "Prime 112" at Brown's Hotel (112 Ocean), Nemo on 1st and Collins, and Mark's at 1120 Collins. And, of course, Joe's Stone Crab (at the southern end of Washington Ave.), if you have the time to wait in line and/or the connections (or the tip-money) to "jump the line."

In the mid-price category, there are a few restaurants which have stood the test of time (and rising rents) because of their serious commitment to good food at a decent value. Among my favorites are: The Front Porch Café on Ocean Drive between 14th and 15th. Sts., where the portions have always been generous and the proprietors have always been justly proud of the quality of their food. The Front Porch also has one of those Ocean Drive sidewalk-eating areas that is in many ways superior to those closer to Tenth and Ocean because it is a little quieter, but still affords an eyeful of Ocean Drive's famous people-parade. The genre of food at The Front Porch Café? I would call it "upscale comfort food" because it tends to include very good renditions of some of the meals that mama used to make – or, at least, that you wished she could make.

Further north, about ten blocks, is Talula (210 23rd. St…a few steps west of Collins…not far from the Library). The food at Talula is gourmet and inventive and worthy of at least one visit.

And, even in the midst of all this self-indulgence, South Beach has also shared in the health-consciousness that has swept the United States. You'll find a gym on every other corner, and South Beach also sports a number of genuine health-food eateries. My favorite, and a good reason to take a walk or bus ride across to the west side of Miami Beach, is "Wild Oats," located at 1020 Alton Road. This is actually a market that provides yummy take-out (sandwiches, salads, etc.). A handful of tables line the entranceway.

I plead guilty, though, to sometimes picking restaurants mostly on the basis of their dessert possibilities. Miami Beach being the island of pleasant choices, there are some choices in how you can go about this. The traditional method is one that you might be accustomed to: Either checking out the dessert menu when you swing by a restaurant during your daytime touring, or making a phone call to see what's on the dessert slate.

There is another way, though, and that is to choose your restaurant based on its proximity to the many dessert-specialty establishments in South Beach. Among other treats, there are at least three genuine Italian ice cream shops now within a South Beach walk. These establishments, as you may or may not know, specialize in a concoction called "gelato," a word which the academics might translate as "Italian ice cream" but I translate as "Heaven." If you've never tasted a gelato cone, you could do a lot worse than plan your dinner location around one of these shops. In the best ones, the show that transpires as the gelato is lovingly rolled around the top of the cone (that's right, a good gelato cone, in true Italian style, is a piece of art to be eaten) is enough to create a lasting memory. South Beach also boasts one of the best "American" ice cream shops in the world. It's called "The Frieze," and it started on Fifth Street back in the eighties but is now located just off of Lincoln Road on Michigan Ave (#1626). They take great pride in their product and are very generous with their tastings. At The Frieze, the flavors are always surprising and the quality can't be beat, even by those artistic Italians. And, by the way, don't forget all those coffee stands and cafés, where you can supplement your dessert with a variety of the world's finest coffee experiences.

South Beach Diners always seem to prefer eating "alfresco."

Lincoln Road restaurant that was once owned by Michael Caine and at that time was called The Brasserie, is now called Touch and has been redone in red and red!

Chapter Eighteen

The Un-Club Scene

Art Openings, etc.

Okay, let's admit that one of the reasons you're considering a South Beach vacation is that you've heard so much about the "club scene." In the estimation of some, the appeal of Miami Beach is now as much about sin as it is about "sun." And there's a lot of truth to what you've heard. The club scene tends to elevate one spot for a year or two and then, for reasons that are not entirely obvious, suddenly turn its back on the same spot, never to return until the name and "theme" of the club-space changes, at which time the cycle starts all over again. As far as the "sin" goes, the cops and other residents are pretty laid back as long as nothing you do harms someone else who's also trying to have a good time in South Beach. One of the problems with the clubs is that you can either go BEFORE the "scene," in which case you'll wonder what all the fuss is about since all there is is a dance-floor or two, hip furnishings, and a terrific sound-system enveloping you in vibration as well as sound. Or you could go DURING the "scene," in which case you'll need to stand in line at any of the "in" clubs, along with everybody else who's read so much about the club scene. There's really not much of an in-between, unless you arrive before the crowd (say 11 PM – that's right, that's early in club-land), and plan to hang out for several hours so that you can see the party at its height at 3 AM or so. This will be expensive (there's likely to be some serious pressure to drink up a tab, since these are profit-making establishments on a good night), but might well be worth it if what you're after is the real club experience. So I'm the last to discourage you from following the club fantasy that brought you here in the first place.

But there's a whole lot more to the nightlife in South Beach than just "clubbing it." In the years since the mid-1980s, the Miami Design Preservation League has been successful in influencing the thinking of the city's officials and citizenry. A real art scene has developed here. Not nec-

essarily what you'd call a "serious" art scene, in the sense of New York or one of the European capitals, but there is now a short but identifiable tradition of South Beach art. For one thing, a number of Miami Beach's artists have become internationally prominent. Probably chief among these is Brazilian-born Romero Britto. Britto, who first became popular in his twenties and now is valued from California to Calais, maintains his long-time central studio/gallery (fittingly enough called "Britto Central") in the 800 block of Lincoln Road. Britto's gallery is worth a visit just because, more likely than not, when you see the consistent style of his artwork, you'll "recognize" it as something that you've seen before. And you may well have seen some of this art before, either in the many commercial applications it has had in advertising and promotion, or in the form of some of the many imitation-Britto items that his work (and great financial success) have spawned. He even has a Britto-themed restaurant in the Royal Palm Hotel, as well as a sculpture at its main entrance on Collins Avenue.

Another South Beach-based artist who also had his early studio on Lincoln Road is Carlos Betancourt. Aside from having been selected by many as a great young Hispanic-American talent, Betancourt has also been selected as one of the "Sexiest Men" in Florida. Unfortunately, Betancourt has recently moved his base of operations to the newly-Bohemian area north of the Miami Design District (which is part of the City of Miami, across the causeways and bridges west of Miami Beach), but his rise as an internationally recognized force in the art world is testimony to the development of the South Beach art scene.

There are other very talented artists that have chosen South Beach as their home, and many of their works are quite affordable — enough so that they make great gifts to bring back home. A large variety of matted prints, posters, jewelry, and even handmade fridge magnets are available to view and to purchase in The Art Deco Welcome Center at Ocean Drive and 10th Street.

A super-sized Britto beachball sculpture sits smack in front of The Royal Palm Crown Plaza Hotel at 1545 Collins Avenue. Britto's Restaurant sits inside, along with more Britto art.

Perhaps the greatest single motivating force for this South Beach renaissance in the arts has been the South Florida Art Center, which was founded back in the 1980s. You'll recall from one of the introductory chapters in this book that South Beach went through a depression, in every sense, during the 1970s and early '80s. Things became so depressed that Lincoln Road, once famed as the most glamorous "open-air shopping mall" in the world, had become a place where nobody wanted to be – not the merchants, not the customers, not the tourists, not even the residents of South Beach. Into this derelict commercial district stepped the South Florida Art Center, a non-profit organization that, in retrospect, has done for Lincoln Road what the Miami Design Preservation League has been able to do for Ocean Drive, Collins, and Washington Avenues. What the Art Center did, and does to this day, is to provide gallery space and stipends for rising-star artists from throughout the United States and Latin America. A few of the then-vacant and decaying buildings were acquired by the Art Center for its gallery space. Most importantly, though, the Art Center brought some LIFE back to Lincoln Road.

In fact, the artist-led revival that the Art Center fostered has resulted in a Bohemian-flavored pleasure promenade along Lincoln Road (as compared to, say, Ocean Drive), another indication of the growing power of artistic sensibilities in the wake of the Preservation League's success in promoting the architectural integrity of South Beach. Partly as a result, Miami Beach hosts or houses a far greater proportion of the region's artistic community than its population or geographic size might justify. Every December, South Beach hosts a stateside rendition of the Art Basel art market so well known in Europe. Both the Miami City Ballet and the New World Symphony, becoming prominent throughout much of the world, are headquartered in South Beach. For those who are more inclined toward the big-stage experience, the Jackie Gleason Theater, at Washington Avenue and 17th Street is the traditional venue of choice within South Florida for traveling shows and midsize-auditorium events.

In addition to providing yet more richness in what you can do here in South Beach, the growth of the artistic community has combined with the vibrance of the area's real

estate and tourist industries to create what I call "the club scene alternative." If you're more than ten years out of your college-age years, you might just be looking for something a little (a) earlier to start; and (b) tamer than the all-out club scene. Most any night of the week – particularly during the weekday nights when the non-tourist social scene is relatively quiet – you can find several South Beach opportunities for your own glamorous outing, and it's usually free of charge. Whether you rely on the local alternative newspapers, the Internet, your hotel concierge or the advice of a resident, a little effort can create for you a night-by-night schedule of art or business-related events (usually from 7 PM on) to attend. And the crowd that gets invited to these events (art gallery openings, business grand-openings, restaurant "previews," outdoor charity events) tends to be as glamorous in its own thirty-something way as the dance clubs are in their twenty-something way. The important thing to remember, both day and night, is that the interior spaces and experiences should not be missed. Whether it's a particular hotel that interests you, or an art gallery opening – step inside – have a look, and enjoy yourself.

South Florida Art Center located at 800 Lincoln Road. Up the road at 924 Lincoln there is another building that houses many additional art studios.

In The End

So, in the end, why come to South Beach?

For the sun. For the beach. For the people-parade. For the clubs. For the outdoor cafés. For the ever-improving restaurants. For its Latin flavor. For its European flavor. For the art. For the sky. For the parties. For the palm trees. For the sea. For the nautical Art Deco buildings. For the fun of it.

That's why.

Kids love it here.

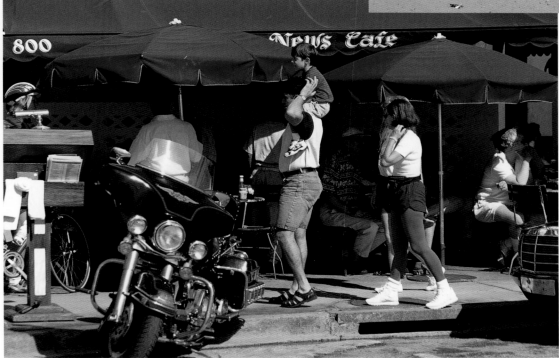

Adults as well as children find Ocean Drive, and its beaches, the best playground around.

One of the loudest and most playful bar scenes (especially for the college crowd) is The Clevelander, located on Ocean Drive and 10th street.

Whether you're taking a power nap in preparation for the night ahead, or just relaxing, our beaches will always give you the "lift" you need.

So when you're feeling blue, think of the colorful things you've seen here…

the colorful things you did here. And come back soon.

Index

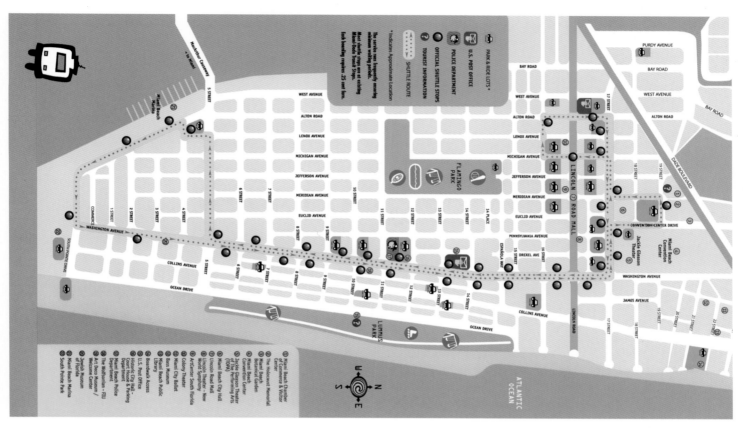

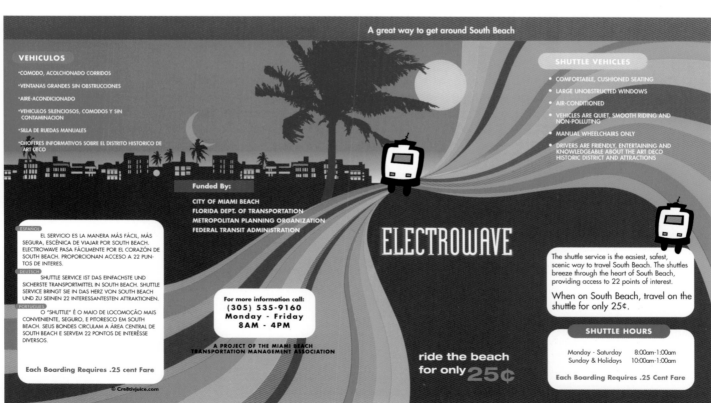

"Never Leaving"

J. Chase '03

Author Biography

Iris Garnett Chase is the Resident Artist at the Miami Design Preservation League's Art Deco Welcome Center. Her own design work has focused on newly fashioned jewelry that incorporates Art Deco era objects, usually made of bakelite. She is also well known for her art-to-wear sunglasses, some of which have covered the eyes of famous people including Elton John. Her designs have been featured in international fashion journals such as *ELLE Magazine*, *LIFE*, and *Florida International*. Her jewelry and wearable art have been sold in New York's Museum of Modern Art, The National Museum of Women in the Arts in Washington, D.C., and many galleries throughout the U.S. Her art-to-wear sunglasses have also been sold at auction by Sotheby's. She is a native New Yorker with two decades as a trend-setter in Washington, D.C.'s fashionable Georgetown neighborhood, where she owned and operated her famous boutique, "Off The Cuff." She often says that her devotion to the Art Deco style can be explained only by the possibility of a prior life. Mrs. Chase lives with her husband, Barry, at 47th and Collins in Miami Beach.

Photographer Biography

Susan Russell is an award-winning photographer who has worked in South Florida since 1975. Her pictures have appeared in major publications, among them *The Boston Globe*, the *New York Times Magazine*, and the *Chicago Tribune*. Her assignments have ranged from the Vietnam War and Arctic Circle to Puerto Rico and Berlin. When she discovered the historic district of Miami Beach, she found that the more she photographed there, the more she was drawn to return. She has been returning for ten years.